*M*eissen

Europe's First Porcelain

Hans Sonntag

Meissen ®

in Meißen

Edition Leipzig

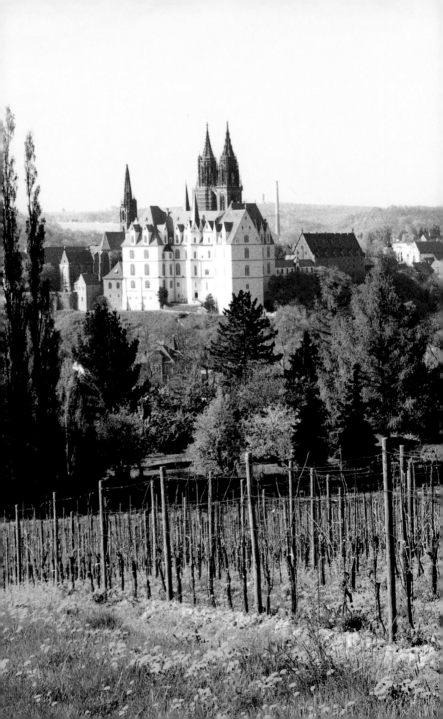

Millennial Meißen

The small city of Meissen (population 30,000) is particularly notable for its charming setting directly on the Elbe and for the towering structure of the castle hill, with the Albrechtsburg fortress, the cathedral and the bishop's palace.

It is set in gentle, hilly countryside, and the old part of the city is dominated by steep, narrow streets, small squares, romantic corners and tiny courtyards. The view from the castle hill or the spire of the Church of Our Lady (Frauenkirche) over the roofs of the centre of the city consists of a haphazard pattern of light and shade.

In the year 929 King Heinrich I (reigned 919–936) had military fortifications built on the rock plateau by the Elbe. Under Emperor Otto I, the Mark of Meissen was created in 965 and was administered by a margrave. The bishopric of Meissen was established in 968. The hereditary title of count of Meissen was conferred by Emperor Heinrich III around 1050. Under Konrad the Great the Wettin royal family gained lasting possession of the margravate of Meissen in 1123.

The city of Meissen developed from the settlements at the foot of the castle hill. As early as 1150 – earlier than other towns in Saxony – Meissen was referred to as a "civitas". The margravial town with its market and the Church of Our Lady was first mentioned in official documents in 1205. According to ancient tradition, celebrations were often held in Meissen. Emperor Heinrich III and Emperor Heinrich IV held great ducal feasts here (1046 and 1071). Armed knightly contests were held. Minnesänger, the minstrels of courtly love, also frequented the castle, and it is even said that the well-known minstrel and poet Walther von der Vogelweide was a guest of Margrave Dietrich the Oppressed around 1212.

Meissen was not destroyed in the Second World War, so a wealth of original architecture – mainly from the Gothic and Renaissance period – was preserved. Although the city was largely

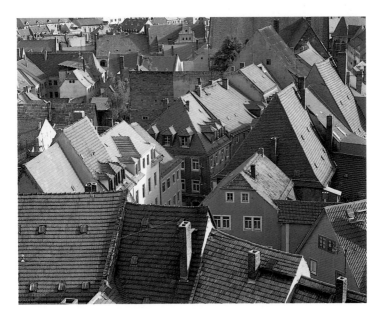

Above the roofs of Meissen

in a poor state of repair before the social upheaval associated with German reunification, it was nevertheless a beloved home to the people who lived here, and at the same time an attraction for tourists from around the world.

Meissen has probably never been as "beautiful" as it is today, but there has never before been so much money available for the preservation of the city.

The city became world-famous because of Meissen porcelain. The first and oldest porcelain manufactory in Europe, which was established in Meissen in 1710, took the name of the city around the world as a descriptive term and even as a trademark. Merely mentioning the name of the city was enough to indicate that this porcelain was something really special.

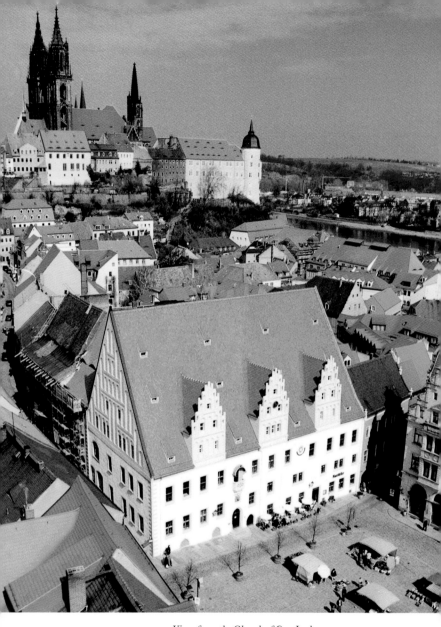

View from the Church of Our Lady

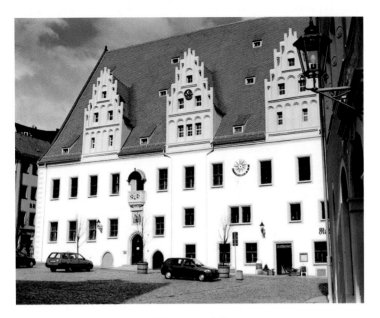

Meissen town hall

It is beyond doubt that the city is worth seeing and visiting. The following remarks on its history and sights are designed to whet your appetite!

The late Gothic city hall dominates the northern side of the market square. Construction work began in 1472, and the building was constructed entirely by Meissen craftsmen. In spite of its structural simplicity, the building appears monumental, mainly because of its towering roof with a ridge height of 18 metres. The city hall convincingly expresses the responsibility and strength of the Meissen city council.

The Heinrich Fountain bears a statue of King Heinrich I with a model of the first fortifications in his hand. The statue was created by the Dresden sculptor Robert Henze (1827–1906) and was erec-

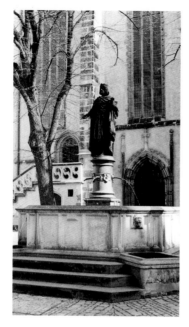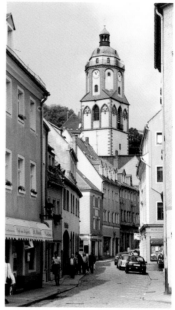

Museum and Heinrich Fountain / Church of Our Lady

ted in 1863 in conjunction with the reproduction of the medieval fountain. In 1989 the original had to be replaced by a replica.

The city museum on Heinrich Square was originally the monastery church of the Franciscan monks. The monastery was originally established around 1258, the Gothic church was consecrated in 1457 and construction was completed around 1500. The building has been used since 1934 as a museum for the presentation of the history of the city.

The Church of Our Lady (Frauenkirche) on the market place goes back to a building which was known as St. Mary's Chapel and was first mentioned in 1205. The present Gothic-aisled church was consecrated in 1457, but construction was not completed until 1520.

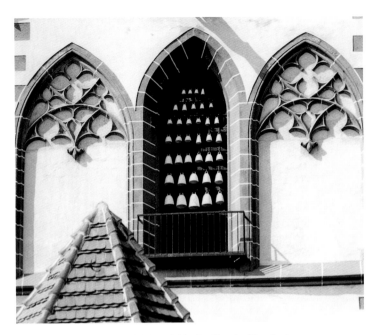

Porcelain Glockenspiel in the Church of Our Lady

Since 1539 it has been the main parish church in the city. Until 1907 a spire caretaker – who lived in the octagonal spire with his family – was on permanent fire-prevention duty.

On the spire of the Church of Our Lady – and visible from the outside – is a Glockenspiel of 37 bells of Meissen porcelain, which was mounted in 1929. It was created by the manufactory artist Paul Börner in connection with the 1,000-year anniversary celebrations of the city. The Glockenspiel can be heard daily at the hours of 6:30, 8:30, 11:30, 14:30, 17:30 and 20:30.

Next to the Church of Our Lady is the distinctive and famous wine tavern "Vincenz Richter". The rooms are adorned with a plethora of objects from the history of the city, which create a

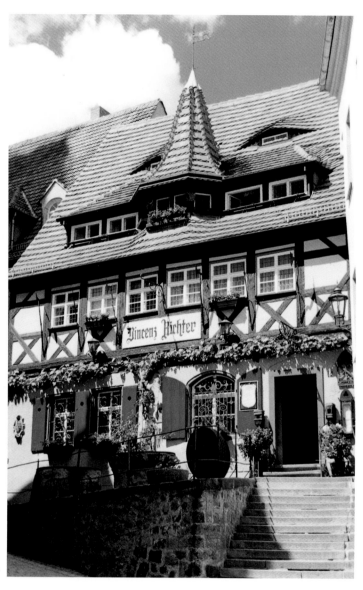

Vincenz Richter wine restaurant

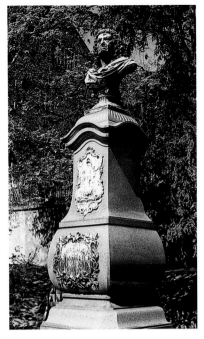

Johann Friedrich Böttger:
Monument with bust by Emmerich Andresen

unique atmosphere. The inner courtyard with its plants is a special attraction, and the torture chamber in the basement will chill the visitor's spine. The building dates back to the clothmakers' guild house of 1523, and the nearby Clothmakers' Gate is also a reminder of this noteworthy city guild.

The Böttger monument was created by the head of the manufactory's design department, Emmerich Andresen (1843–1902). It was ceremoniously unveiled on October 17, 1891. It was originally erected on Neugasse (near the Sparkasse bank of today) opposite the house of Arthur Kirstein at Neugasse 59. Since 1912

the monument has been opposite the main entrance to the manufactory.

Construction work on Meissen cathedral began around 1260. Services were already held in the high chancel in 1290. The western portal was built in 1370. The ducal chapel outside the western structure has been the burial crypt of the Wettin family since 1429. The small St. George chapel was added at the side of the cathedral between 1521 and 1524.

Arnold von Westfalen, the master builder of Albert's fortress, built the third floor of the spire between 1470 and 1480, but it was destroyed by lightning in 1547.

The finely structured western spires that can now be seen were completed between 1903 and 1908 according to designs by the Karlsruhe architect Carl Schäfer.

The famous literary figure Johann Wolfgang von Goethe visited Meissen cathedral on April 20, 1813, and wrote to his wife Christiane: "The cathedral, which is situated in the same place, has no attraction on the exterior for several reasons, but in its interior it is the most slender and beautiful of all buildings of the period that I know. It is not darkened by any monuments nor spoiled by any raised galleries, painted in a yellowish colour, illuminated through white panes of glass, and only the single middle window of the chancel has been preserved as a coloured window. In this very chancel I found the stone-hewn canopies above the seats of the cathedral canons striking and new. They are like chapels and castles that float in the air, and the spiritual and knightly motifs always alternate. A very fitting decoration if we remember that the cathedral canons were originally of old knightly stock and the chapel spires were due to them. I have made a sketch which gives an impression that no description could convey to anyone …"

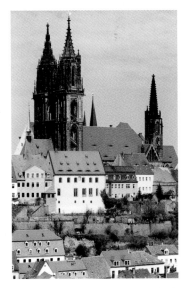
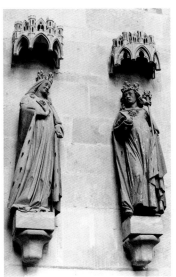

Meissen cathedral and its founder figures:
Emperor Otto I and Empress Adelheid

From an art history point of view, the figures of the patron saints of the cathedral which are situated above head height in the chancel are particularly important. They show Bishop Donatus, St. John the Evangelist and the donor, King Otto I and his wife Adelheid. The sculptures, which are larger than life size and were created around 1260, are associated with the workshop of the Naumburg master.

The altar and cross of 1526 in front of the choir screen come from the Cranach workshop in Wittenberg. The altar accessories – a crucifix and two candlesticks of Meissen porcelain – were created by Johann Joachim Kaendler.

On the castle fief house, a plaque commemorates the sketch artist and painter Adrian Ludwig Richter (1803–1884), who worked

Commemorative plaques: Ludwig Richter, Am Burglehn / J. J. Kaendler, Domplatz

as a drawing teacher at the Meissen manufactory and lived in this house from 1828 to 1836.

On the house at Domplatz 8, a plaque recalls the master modeller Johann Joachim Kaendler, who purchased the house in 1740, converted and altered it in 1745 and lived here until his death in 1975. His place of work was just a few steps away from the house.

The commemorative plaque on the house Domplatz 10 points out that the painter Georg Friedrich Kersting lived in this house. From 1818 until his death in 1847 he worked as the head of painting at the manufactory. His work provided an important impetus for Meissen porcelain painting in the 19th century.

Johann Gregorius Höroldt came to Meissen in 1720. We owe the brilliant colours of Meissen porcelain to him because he was both a paint chemist and a painter. Until 1765 he had a major influence on Meissen decorative arts in all genres. This plaque was mounted on the front building in 1996 on the 300th anniversary of his birth in Görnische Gasse 1.

The Albrechtsburg fortress, which was named after Duke Albrecht of Saxony as of 1676, is regarded in its present condition as the most important secular late Gothic building in Germany, with the early character of a castle.

Georg Friedrich Kersting, Domplatz / Johann Gregorius Höroldt, Görnische Gasse

The task of creating an administrative, representational and residential building for the rule of the Wettin family on the restricted and uneven space and of integrating parts of the mediaeval fortifications was brilliantly solved by the master builder Arnold von Westfalen. The special features of the building include the enormous outer-aisle arch windows, the new building technique of the cell-type vaults and the splendid staircase tower known as the "Grosser Wendelstein".

The Albrechtsburg was built for the two brothers who ruled together until 1485, Elector Ernst (ruled 1464-1486) and Duke Albrecht (ruled 1464–1500), and was thus designed for two separate courts and a joint state administration. Construction began in 1471 after designs by the Saxon senior master builder Arnold von Westfalen and under his supervision, and it continued until 1525 with an interruption between 1498 and 1520. After von Westfalen died, the master builders Konrad Pflüger (as of 1482) and Jakob Heilmann von Schweinfurth (1520–25) worked on the completion of the building. During the last phase of construction, Duke Georg of Saxony moved the residence of the Wettin family to Dresden after he came to power in 1500, which meant that the Albrechtsburg never actually served the function it was originally designed for.

Wall painting by Paul Kießling, around 1880, in the Böttger room in the Albrechtsburg
"Elector Augusto Being Shown the Secrets of the Factory. 1710"
"J.F. Böttger Working in the Fortress on Gold. 1705."

In June, 1710, August the Strong, the Elector of Saxony and King of Poland, established the first porcelain manufactory in Europe in the Albrechtsburg. The famous Meissen porcelain was produced in the entire complex of rooms of the Albrechtsburg until 1864. The new technical manufacturing facilities of the 19th century led to fears that the Albrechtsburg, as a major architectural monument, could suffer damage, so it was agreed to move the manufactory to a new production site.

From 1873 onwards, the castle rooms were gradually decorated, with wall paintings, for example, which glorified the history of the house of Wettin. Today these wall paintings are highly regarded as examples of historical painting of the late 19th century, particularly

18

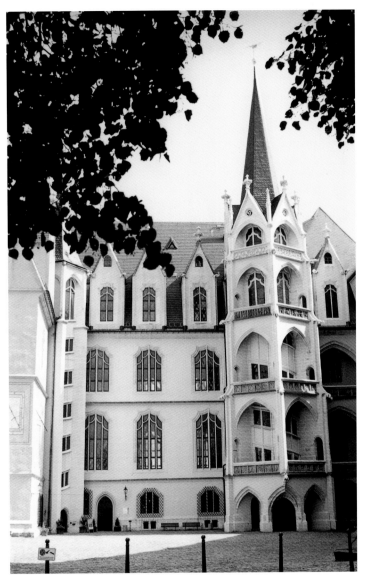

The Albrechtsburg from the courtyard

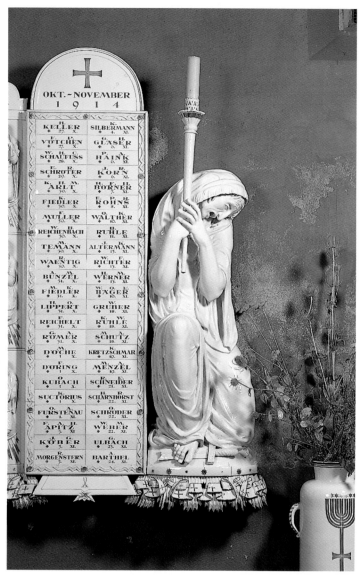

Porcelain designs by Emil Paul Börner
in the Nikolai church in Meissen

as the thematic coherence of the paintings is unique in Saxony. The artists – such as Paul Kießling (1836–1919), August Spiess (1841–1923), Alfred Diethe (1836–1919) and Anton Dietrich (1823–1904) – were famous painters in their day. This extensive decoration project to make the Albrechtsburg into a site commemorating Saxon history was prompted by the 50th-anniversary celebrations of the Saxon constitution in 1881 and the festivities of 1889 in honour of the 800th anniversary of the Wettins' accession to power.

In the small romantic St. Nicholas church (Nikolaikirche) by the city park (near the porcelain manufactory), 2.25 metre high figures made of Meissen porcelain can be seen. From 1921 to 1929, this church was made into a memorial site for those who fell in the First World War. The manufactory artist Paul Börner designed the figures, the memorial plaques with the names of the approximately 2000 persons who had fallen and other interior design elements – all made of Meissen porcelain. This memorial site was dedicated as part of the celebrations of the 1000-year anniversary of the city of Meissen in 1929.

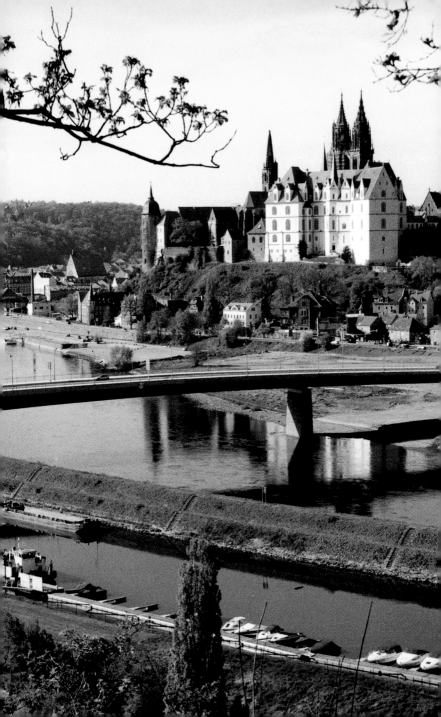

The history
of the Meissen Porcelain Manufactory
from the 18th century
to the present day

The invention of European porcelain in Dresden was the result of many years of systematic experiments to explore the secrets of the production of east Asian porcelain. The highly developed skills in mining and foundry work in the Saxon Erzgebirge mountains formed a basis for success. Famous scholars such as Tschirnhaus and Pabst von Ohain, mining and foundry experts and the alchemist Böttger were all involved in the research.

First of all, in 1707/08, the researchers succeeded in producing a densely sintered red stoneware. Then, in 1708, came the year that is regarded as the birth year of white European porcelain (a laboratory record of January 15, 1708, contains a note on the first white paste batch).

"The New Welcome", modelled by Johann Jacob Irminger, around 1714

Ir Friedrich AUGUSTUS von GOttes Gnaden / König in Pohlen/ Groß-Hertzog in Litthauen / Reussen/ Preussen/ Masovien/ Samogitien/ Kyovien/ Volhynien/ Podolien/ Podlachien/ Lieffland / Smolenscien / Severien und Tschernicovien 2c. Hertzog zu Sachsen/ Jülich/ Cleve/ Berg/ Engern und Westphalen/ des Heil. Römisch. Reichs Ertz-Marschall und Chur-Fürst/ Landgraf in Thüringen/ Marggraf zu Meissen/ auch Ober- und Nieder-Lausitz/ Burggraf zu Magdeburg/ Gefürsteter Graf zu Henneberg/ Graf zu der Marck/ Ravensberg und Barby/ Herr zu Ravenstein/ 2c.

Thun hiermit kund und fügen männiglich zu wissen: Demnach Wir Unsers getreuen Churfürstenthums und dahin incorporirter/ auch anderer Lande bekümmerten Zustand/ darein dieselbe durch mancherley Unglück/ insonderheit durch die vor vier Jahren beschehene Schwedische Invasion gesetzet worden / mitleidend beherzciget/und hierauff/wie solchen auffs beste und nachdrücklichste wieder auffgeholffen werden möge/ Unsere einzige und höchste Sorge seyn lassen; So haben Wir unter andern ausgefundenen Mitteln/ daß die Wiederbringung einer gesegneten Nahrung und Gewerbes im Lande hauptsächlich durch Manufacturen und Commercia befördert werden könne / vornehmlich in Consideration gezogen und Unsere Landes-Väterliche Sorgfalt dahin gerichtet/ wie die von GOtt Unseren Landen besonders reichlich mitgetheilte unterirrdische Schätze eiferiger / als in vorigen Zeiten nachgesuchet/und diejenigen Materialien/ so als todt und unbrauchbar gelegen/ zu ein oder den andern Nutzen gebracht werden mögen. Und Wir dann/ nachdem Wir sothane Nachforschung einigen/ in dergleichen Wissenschafften vor andern wohlgeübten Personen auffgetragen/ und diese auch bißhero ihre Erfahrenheit

A und

Foundation decree for the porcelain manufactory in Meissen
dated January 1710

On January 23, 1710, the court chancellery announced in a "highest decree" in Latin, French, German and Dutch that in electoral Saxony "vessels can and should be made which are equal to East Indian porcelain both in their transparency and in their other required qualities" and that the production of such vessels in a manufactory should be "put into practice, the sooner the better."

Ehrenfried Walther von Tschirnhaus,
likeness in the Böttger room in the Albrechtsburg in Meissen

Ehrenfried Walther von Tschirnhaus (1651–1708) was a mathematician, natural scientist and technologist. After his studies in Leiden and cultural journeys to England, France and Italy, which gave him personal contact with Colbert, Leibniz and Spinoza, he began his experiments with burning reflectors and burning lenses to generate high temperatures. From 1693/94 onwards he also worked on the problem of porcelain production. Alongside Böttger and Pabst von Ohain, he is regarded as a pioneer of European porcelain production.

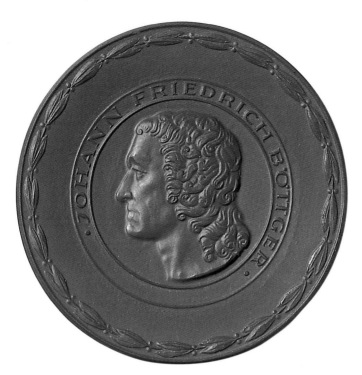

Johann Friedrich Böttger,
Böttger stoneware picture medallion

Johann Friedrich Böttger (1682–1719) originally trained as an apothecary and then made a name for himself as an alchemist and a maker of gold. Starting in 1701, he worked as an alchemist in Dresden, Meissen and Königstein. In November 1707 he was allocated the building of the Jungfernbastei in Dresden as his place of work and his home. On March 28, 1709, Böttger presented a written report to the court in which he announced the invention of European porcelain. He went down in history as the inventor of European porcelain.

At the court of the Saxon Elector Friedrich August I, who was also King August II of Poland as of 1696, scientists, architects, jewellers, painters, musicians, theatrical staff, sculptors and others from many different countries worked to make Dresden into a first class royal residence. This splendid era is known as the "Augustian age" because the Elector king, known as August the Strong, and his son, Elector Friedrich August II, made their mark on many aspects of courtly life with their sophisticated modern ideas.

But the wealth of the state was still based on the considerable amount of silver and tin ore found in the Erzgebirge mountains. The goal of promoting numerous manufacturing plants was to utilise the natural resources in a profitable way. The Polish-Saxon union was in the final analysis an enormous financial burden for the Electorate, which meant that August the Strong constantly had to be on the lookout for new sources of funding. His porcelain manufactory in Meissen was intended to help; first of all he aimed to save money by producing porcelain himself, and secondly he aimed to make a profit from sales. It was the first porcelain manufactory in Europe, and all the European royal families required vessels made of porcelain.

The small colourful statuette not only shows August's coronation regalia in Krakow, it also portrays the Elector king as an emperor full of vitality and dynamism.

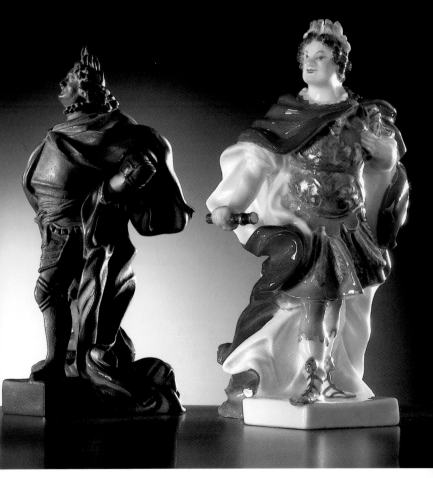

August the Strong as a chess piece in "German Armour" (Böttger stoneware, left) and in "Roman Robes" (right). Modelled by Johann Joachim Kretzschmar, 1714.

The Albrechtsburg in Meissen – far from the residence city of Dresden – seemed an ideal site to keep the production secret (arcanum) of porcelain hidden for a long time. The entrance through the fortress gates was easy to guard, the proximity of the river made it simple to transport wood, the buildings were not in use and had large rooms in the basement vaults and the upper storeys – all of these factors made it an admirable place to set up the porcelain manufactory. On May 6, 1710, it was ordained that the fortress should be vacated, and the director of the manufactory, Michael Nehmitz, took over the premises four weeks later. In November, 1711, the manufactory had a staff of 25, but the establishment of the production site was slow to progress. Böttger, the administrator, was in Dresden and only rarely came to Meissen.

On April 21, 1714, on his way to the Leipzig exhibition, August the Strong stopped at the Albrechtsburg with various Polish magnates and Saxon cavaliers. They reached the fortress at 6 o'clock in the morning, took breakfast together in the large hall and then inspected the production facilities in the presence of Johann Friedrich Böttger. They continued their journey at 9 o'clock. Two days earlier, on April 19, August the Strong had given Böttger his freedom again after almost thirteen years of captivity, but he made him swear an oath not to leave the state of Saxony and to keep secret the arcanum of porcelain. A year before, in 1713, the first white porcelain had been sold at the Easter fair in Leipzig, thus achieving the breakthrough.

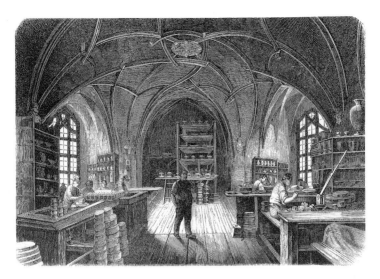

Room of the throwers in the Albrechtsburg, wood engraving, around 1860

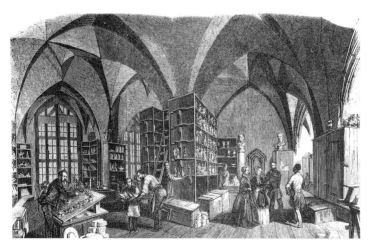

Room of the painters and gold platers in the Albrechtsburg, wood engraving, around 1860

31

The daintiness of early porcelain

Johann Jakob Irminger, who lived in Dresden from 1682 on and worked as the court jeweller as of 1687, is regarded as one of the first artistic designers of the new ceramic material. Possibly Irminger was one of the artists who visited Böttger at the Jungfernbastei as early as 1708. In a report on the early period of the manufactory it is claimed that even before the manufactory was moved to Meissen, the potter Peter Geithner "was taught how to turn the ware with a rotating base by a goldsmith called Irminger who was skilled in turning silver ..." in the house of Dr. Bartholomäi. In a letter to the Elector king dated May 29, 1713, Irminger wrote that the king "saw fit about 3 years ago to instruct me by word of mouth to lend a helping hand with your porcelain factory ..."

To judge by the exhibits in the royal collection, imitations of East Asian shapes were dominant at first, but then the existing shapes of gold, silver, tin and ivory art were also transferred to the fine red stoneware or white porcelain. Irminger's innovative principle of decoration, with textured applications of blossoms, branches, leaves, tendrils, etc., suited the preference for "daintiness" in European porcelain.

The range of porcelain paints suitable for firing was limited in the early period of the manufactory, so many items were decorated with unfired (i. e. "cold") paints.

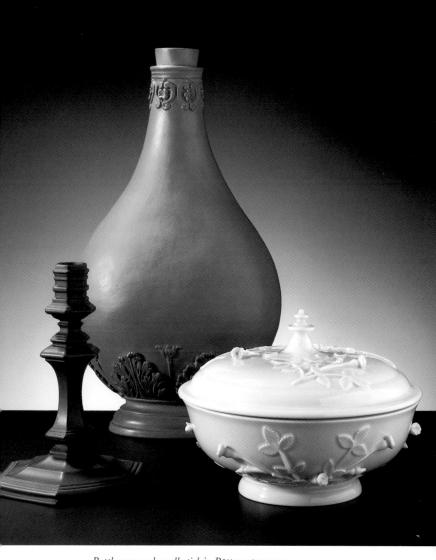

*Bottle vase and candlestick in Böttger stoneware
and covered dish with relief pattern in Böttger porcelain,
modelled by Johann Jakob Irminger*

The constantly growing porcelain collection of August the Strong required an extravagant means of display. The "Dutch Palace" was no longer adequate for the purpose, so in 1722 Zacharias Longuelune began work on plans for an extension of the palace. The foundation stone for the conversion work was laid in 1727. Beginning in 1728, Jean de Bodt contributed plans for the building work. The four-wing complex with an inner courtyard was completed in 1733.

The "Japanese Palace" was designed exclusively as a porcelain palace and was to surpass by far the dimensions of all similar establishments. The Meissen porcelain manufactory worked on innumerable special orders such as the large animal figures. In 1732, August the Strong ordered 910 large and small porcelain animal figurines with tops, vases, dishes, etc. The manufactory supplied a total of 35,798 porcelain items for the decoration of the "Japanese Palace". Besides Chinese and Japanese porcelain, the Meissen porcelain items were especially meant to reflect the skill and unmistakable beauty of the manufactory's own work.

This idea is graphically illustrated in the gable triangle of the palace: the goddess Minerva places the winner's prize for the competition into the hands of Saxony.

With the death of August the Strong in 1733, interest in this extraordinary building and its precious interior dwindled and was lost.

Large animal figure "Monkey with Young", modelled by Johann Gottlieb Kirchner, 1733

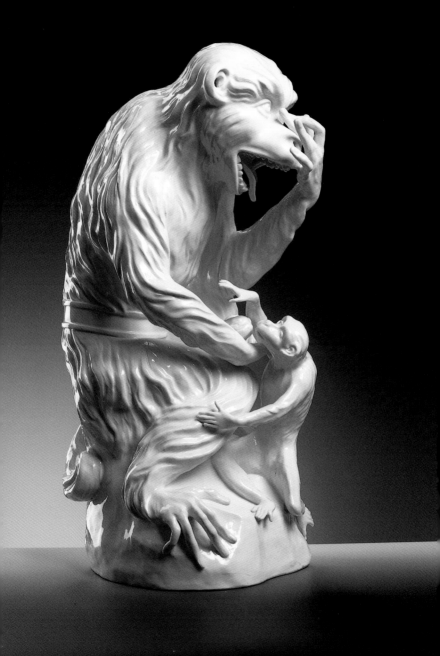

In May, 1720, the twenty-four-year-old Johann Gregorius Höroldt (1696–1775) came to Meissen. As a freelance artist and in his own painting studio, he finally gave Meissen porcelain its brilliant colours. As both a paint chemist and a painter, Höroldt not only developed a wide range of porcelain paints that could be fired, but he also used them himself in innumerable artistic decor designs.

Only four years later, he was promoted to the post of court painter because of his achievements in the artistic design of Meissen porcelain. In 1731 he was finally given permanent employment at the manufactory; he took over the leadership of the painting department and at the same time became an arcanist, i.e. a bearer of secrets; in 1749 he was promoted to the post of mining councillor. His decorations, which were not exhausted by the Chinese motifs, became more and more elaborate and complex as a result of the newly developed paints and his artistic talent, and thus they corresponded exactly to the taste of courtly society. His paintings – Chinese motifs, flowers, hunting scenes or motifs based on Watteau or Boucher – contributed much to the growing world-wide reputation of Meissen porcelain. As a result, Höroldt is regarded as the founder of European porcelain painting. The 300th anniversary of his birth was copiously celebrated by the Meissen Porcelain Manufactory in 1996 – and professional copies of selected works from his period were made by modern artists.

Clock cases with Chinese motifs, probably modelled by Johann Gottlieb Kirchner,
left: casting around 1727; right: casting of 1995/96

The first European texts about coffee and the oriental enjoyment of coffee can be found in the travel accounts of western travellers to the Orient in the 16th and 17th centuries. For a long time, Europe knew coffee only from hearsay. In the second half of the 17th century Greek, Armenian and Turkish traders began to serve coffee in several European cities. Following the example of Venice, which had its first public coffee house as early as 1645, coffee houses were also established in other trading centres from the middle of the 17th century on, for example in 1652 in London, in 1663 in The Hague and Amsterdam, in 1675 in Paris and in 1683 in Vienna. The first German coffee house opened in 1677 in Hamburg, and in 1694 the coffee house "Zum Coffeebaum" opened in Leipzig. With the visit of the Turkish ambassador Soliman Agas to the court of the "Sun King" in 1669, the exclusive passion for coffee finally began in courtly circles. In the coffee ceremony they found a new form of social conversation. And as the Meissen Porcelain Manufactory was the first of its kind in Europe, it now had the task of creating porcelain vessels which would both meet the luxury requirements of courtly society and the general requirements of the market. Meissen can take credit for cultivating coffee drinking with its development of a porcelain tableware culture with matching shapes and decoration. The term "flower coffee" eventually became a synonym for enjoying coffee from flower-decorated Meissen porcelain – and this term can still be heard today.

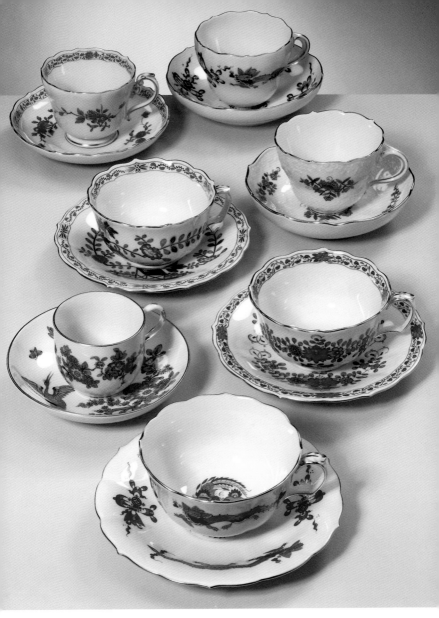

Various cup forms with "Indian" decorations

Far Eastern decors with their colours, arrangements, plants, animals, stones, mushrooms, human figures, etc., contain aesthetic messages which particularly express the wish for longevity, health, wealth, happiness, and also general models of existence, time sequences, etc. A number of symbols were known in 18th-century Europe from various accounts of journeys through East Asia. We now know that the grouse motifs represent a symbol of marriage, that the crane is a symbol of longevity, that the butterfly symbolises the age of eighty, that the dragon was a symbol of fertility and of the emperor, that the flowers represented various seasons, that the colour red had a protective function and that geometric subdivisions of the decors expressed a specific concept of the world, e.g., the trinity of nature (beginning, middle and end; father, mother and child; past, present and future), the number four expressed the times of day, the seasons and the points of the compass and eight was a mediation principle between the cosmos and the earth.

Although some of the original motifs changed in the Meissen decorations, numerous references to oriental culture and philosophy can still be found. The exotic strangeness of the representations was an expression of the enthusiasm for China in 17th- and 18th-century Europe, which was reflected in many different spheres of life, such as fashion, architecture, interior decorations, drinking customs, etc. European porcelain with its decors admirably illustrated this luxurious longing for the faraway, for colourful splendour.

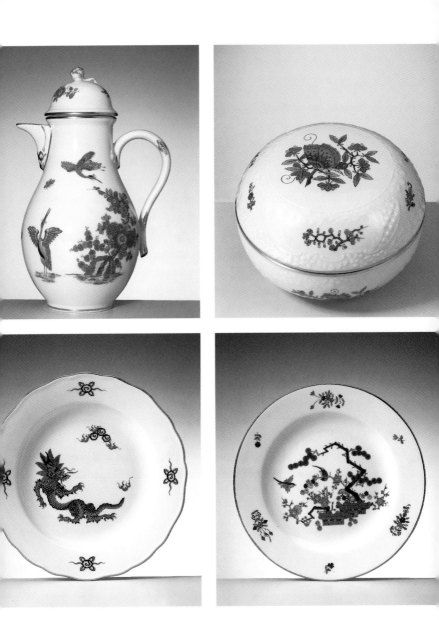

Coffee pot with decor: "Old Indian Flower and Crane Paintings"
Round covered dish with decor: "Chinese Butterfly"
Plate with decor: "Ming Dragon, Black"
Plate with decor: "Indian Branch Pattern"

The so-called onion pattern goes back to an old Chinese decor design. Since about 1739 it has been applied in cobalt blue underglaze painting at the Meissen porcelain manufactory in the version that is still known today. The onion pattern does not contain any onions, rather it portrays four pomegranates and four peaches as symbols of fertility and longevity in a meaningful parable of life.

The term onion pattern was probably only coined in the 19th century.

The decor was and is extremely popular – it can be regarded as the most popular Meissen underglaze painting decor.

The range of products with onion pattern decorations currently comprises more than 700 articles. It is not only the blue and white composition with its fresh, clean atmosphere, but also the high functional value of the porcelain (with its dishwasher-safe decor) which makes this decoration a favourite. Although all items appear identical in decor, the hand painting creates individual characteristics. The genuine Meissen onion pattern is an expression of an elegant table culture full of traditions. There are no bounds to its imaginative use, whether in the kitchen, in a country house or on a festively laid table.

Today, the Meissen onion pattern is imitated and counterfeited all over the world. Only the original is created in the Meissen Porcelain Manufactory.

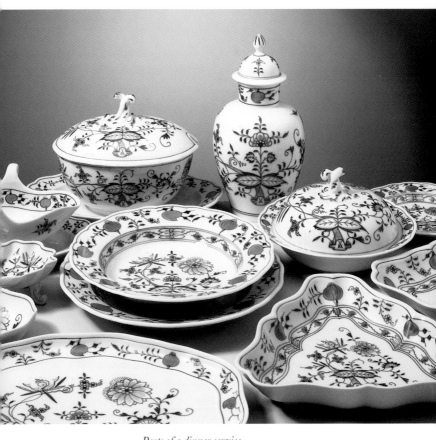

Parts of a dinner service,
"New Cutout", modelled by Johann Joachim Kaendler, 1745 (and later),
decor: Onion Pattern (from 1739 onwards)

Johann Joachim Kaendler (1706–1775), who was trained in the Dresden sculpting and woodcarving workshop of Benjamin Thomae, played a role in the artistic decoration of the "Green Vault" in the Dresden Palace from 1725 onwards and was very familiar with the latest artistic forms of the baroque and the rococo. In 1731, Kaendler moved to the Meissen Porcelain Manufactory on the orders of the Elector king, and he initially took on the complicated work on the large baroque animal figures. During his first five years he worked almost entirely on figures for the "Japanese Palace". Around the middle of the 1730's, the rapid development of playful small porcelain sculpture set in. In 1733 Kaendler became a master modeller, in 1740 he became the head of sculptural form design, in 1741 he became an arcanist (bearer of secrets), and in 1749 he became a court commissioner.

Reproductions of the figurines from all spheres of life created by Kaendler and his staff still meet with great interest among the adherents of Meissen porcelain, for example, the "Paris Criers". These figurines reflect the society of the 18th century in miniature. Formerly, these figurines adorned intricate display cabinets and enlivened elegantly set tables. Today the figurines are mainly interesting from the point of view of cultural history because they bring a bygone age back to life again. Many figurines were designed as thematic series and are still produced today, so that many collectors wish to own complete series.

Figures from the series "Paris Criers",
modelled by Johann Joachim Kaendler, Peter Reinicke, 1744 and 1760

A new tableware culture arises and continues

East Asian porcelain in particular brought longed-for colour to the table culture of the 18th century. The invention of European porcelain made it possible to design extensive tableware services for table setting designs according to individual aesthetic ideas and usage. Gradually, a uniform shape and decoration principle was developed for all items in a tableware service. Johann Joachim Kaendler created not only the different forms of the vessels, he also created the widely varying surface textures. Forms, surface textures and decoration finally created an aesthetic ensemble. Kaendler worked for the Meissen Porcelain Manufactory for the rest of his life and

Plate with relief "Ozier", probably modelled by Johann Friedrich Eberlein, 1736, decor: Old Rich Yellow Lion
Plate with relief "Neubrandenstein", modelled by Johann Friedrich Eberlein, 1741, decor: Old Style Fruit and Flower Painting

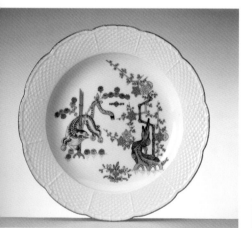

developed the modelled porcelain style characteristic of Europe. His form developments exist even today, and they are still faithfully reproduced in the typical manner of the Meissen Porcelain Manufactory – created meticulously and in great detail by hand – and it seems only natural that they fulfil modern aesthetic and functional requirements without our being aware of this phenomenon. The current range of tableware, candlesticks, mirrors, dishes, vases, etc., is overwhelming in its variety and versatility.

Individual table design with Meissen porcelain has always had a special flair. The colours, light and forms produce an aesthetic effect that can hardly be ignored.

Plate with relief "Gotzkowsky", modelled by Johann Friedrich Eberlein, around 1741, decor: Gold Etched Flowers
Plate with relief "Marseille", modelled around 1745, decor: Multicoloured Watteau-style Figure-painting

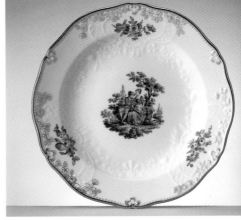

There is hardly any sphere of life to which Meissen porcelain is unable to adapt – both in the past and in the present.

In the 18th century, for example, this applied to snuff boxes, pin tins, grit boxes and potpourri bowls filled with blossoms and spices which gave fragrance to the air in a room. The trembleuse cup was mainly used for drinking in bed – when the user was at least in a half-reclining position – so that the circular insert for adjusting the position of the drinking vessel prevented it from slipping. The movable pagoda figures served as decorative elements in rooms decorated in the Chinese style. They were an attractive toy and at the same time unusual smoking vessels.

The 19th century saw the creation of many kinds and shapes of petroleum lamps, expressive lampshades with popular pictures, fidibus holders and a large number of laboratory devices.

The creations of today include modern potpourri dish designs, clock faces with intricate miniature paintings and wafer-thin sequins for the Haute Couture fashions of Paris.

Porcelain, as a material which was developed in the 18th century, has an infinite number of possible uses even today which can satisfy the most unusual of requirements.

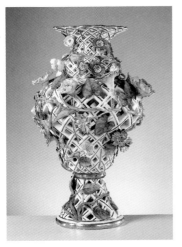
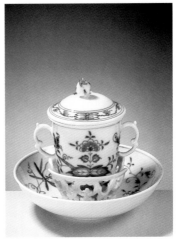
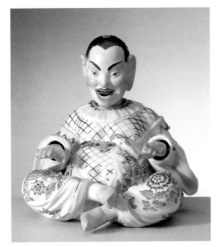

Vase as potpourri bowl, pierced pattern with blossom relief;
mid-18th-century
Trembleuse cup (drinking vessel), decor: Onion Pattern
Pagoda (movable fitting), modelled by Johann Joachim Kaendler and
Johann Friedrich Eberlein, around 1740

49

Every detail of Meissen porcelain design has its aesthetic significance. Embossed flowers on clock cases recall the transience of life, an open bird cage in the hand of a shepherd signifies the capture of his beloved, a basket of broken eggs symbolises the loss of virginity, a painted rose or forget-me-not are symbols of affection and love. The lemon was regarded as a symbol of longevity and eternal youth, like the "golden apples of the Hesperides". The snowball flower was a symbol of variety within unity. The letters and the year on the wine vessel held by the harlequin referred to the Saxon harlequin represented by Joseph Ferdinand Müller. The Freemason groups recall a movement which aimed to create a humanistic society. The pug dog was a symbolic animal of the Freemasons.

Each age contributed its own concepts and demands of the Meissen porcelain designs, a process which still continues, both in the figurines and in the painting designs. And it is this very love of detail with the corresponding meanings that makes Meissen porcelain so interesting and unique. There is always something new to be discovered, and the publications of the manufactory in particular offer a wide range of stimulating ideas in this respect.

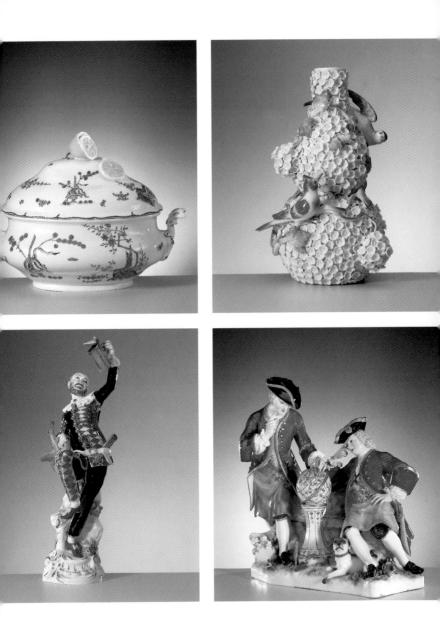

Soup Tureen with Lemon Knob, model and decor: 18th century
Vase with Snowball Blossom Pattern and Birds in the Branches, modelled: 18th century
Dancing Harlequin with Wine Tankard modelled by Johann Joachim Kaendler, 1764
Group of Freemasons with a Globe, modelled by Johann Joachim Kaendler, 1741/42

A new type of flower painting based on copper engravings from about 1735 onwards extended the successful range of "Indian Flower Painting" based on oriental models. The earliest kind was called "Shaded Flowers" because the shaded edges of the models were also transferred to the porcelain. Later, the term "Dry Flower Painting" came to be used, and the shaded edges were usually not included. Around 1745, so-called "German Flower Painting" developed, which also took inspiration from copper engravings but gave more scope for freer composition. The linear outlines are here almost completely omitted, and artistic design achieved with colour is dominant. There soon developed a "Stylised Flower Painting" style with rules in which the primary and secondary flowers, the use of colours, the number of flowers and their position on the painted surface were strictly prescribed. Over time, a wide variety of flower paintings arose which reflected certain approaches to design in the respective artistic styles, such as Marcolini Flower Painting during the classical period, scattered flowers and rose paintings in the Biedermeier period, naturalist and impressionist flower painting, flower paintings in the Art Nouveau style (known in Germany as "Jugendstil") through to the flower designs of the present. All Meissen flower paintings that have ever arisen are included in the manufactory's range of decors, and they can be adapted to suit the preferences of the purchaser. Because of the wide range of painting types, it became necessary for the painters to specialise in various styles.

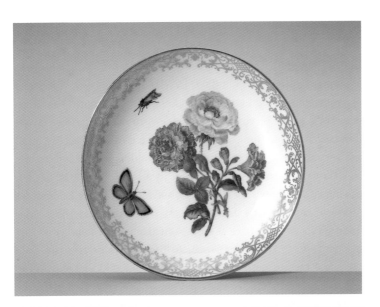

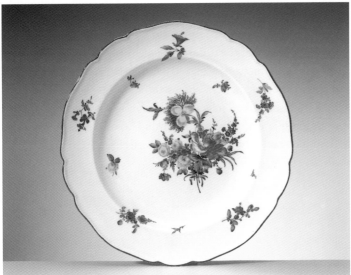

Plate with decor: "Old Style Flower Painting Based on Copper Engravings"
Plate with decor: "Old Style Multicoloured German Flower Painting"

In 1745, Johann Joachim Kaendler developed a form which came to be known as the "New Cutout". In May 1745 he noted: "Produced one new model for a plate which is shaped around the edge, whereby a whole service is to be made with natural (painted) blue flowers." It was a dinnerware service. The term "Cutout" referred to the process of cutting out the corresponding edge shape from a basic circular form. As can be seen in Kaendler's report, he first developed the shapes for the plates, and later he created shapes for serving plates, bowls, dishes, etc. If we reconstruct the shape-finding process, we arrive at a blossom arrangement with alternating narrow and wider petals which form the respective curves in the edge. The flower painting in a cobalt blue underglaze painting technique thus perfectly matched the shape. The design of the flowers was in keeping with the genre of "German Flower Painting". It was painted with a brush on the fired body of the plate. As the porous body immediately absorbs the paint, it is extremely complicated to paint the different shades of light and dark colour. After painting, the work is glazed and the glaze is fired at 1450°C, and finally the blue pattern shines through the glaze. "Blue German Flower Painting" refers to the time when the manufactory had almost perfectly mastered cobalt blue underglaze painting, both in its artistic style and in the firing techniques.

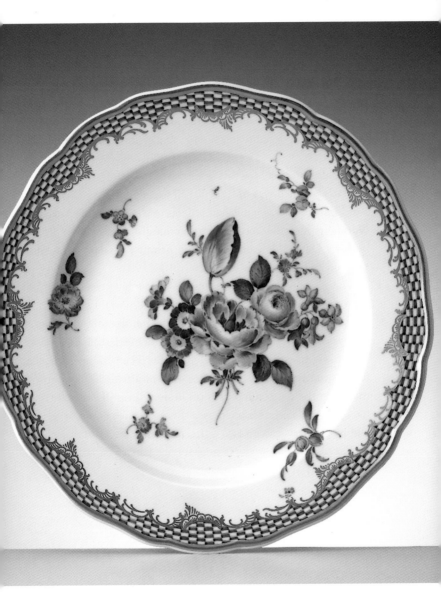

Plate with decor: "Old Style Blue German Flower with Box Mosaic"

From 1737 to 1741 the sensational "Swan Service" was produced for the cabinet minister Heinrich Graf von Brühl. With about 2000 parts it is regarded as the most extensive, and probably the most spectacular, porcelain service of the 18th century. The most notable designers were Johann Joachim Kaendler and Johann Friedrich Eberlein.

The direct model for this design motif was a drawing by Francis Barlow which was first published as an engraving by Wenceslaus Hollar and was published in 1700 in a handbook for artists in Nürnberg. Kaendler received further design stimulus from designs by Juse Aurèle Meissonier and the painting "Galatea in a Shell Wagon" by Francesco Albani.

The service covers a wide range of symbolic representations revolving around the concepts of birth and mortality. The central motif is water, which was regarded as one of the four elements of life, especially flowing water as a symbol of everlasting life.

For several years now, the Meissen Porcelain Manufactory has reproduced the "Swan Service" as a faithful replica, thus proving that even the most complex form designs are still perfectly mastered today. The range includes a dining service and a coffee, tea and mocha service with two different painted decors.

The old versions of the famous service achieve fantastic prices in the auctions of the world today.

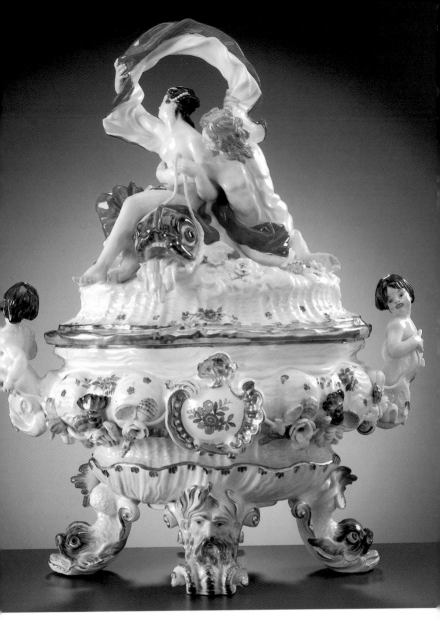

Small Soup Tureen from the Swan Service,
modelled by Johann Joachim Kaendler, Johann Friedrich Eberlein, 1737–1741

The figurines of the Commedia dell'arte are small figurines which throw light on culture and cultural history and are highly prized – and often passionately collected – by theatre enthusiasts and theatrical experts. With their Commedia dell'arte figurines, the famous porcelain figurine designers Johann Joachim Kaendler, Peter Reinicke, Johann Friedrich Eberlein and Friedrich Elias Meyer designed a topical and very popular artistic form in the theatrical world of the baroque and rococo age. In the works of the Meissen manufactory, part of the aesthetic identity of the Commedia dell'arte is preserved in the form of these three-dimensional figurines. The first such figurines were already being produced around 1710/12 in reddish brown fine stoneware ("Böttger stoneware"), and some parts of the figurines were polished. Over the decades and the years, the above porcelain designers created numerous figurines and self-contained series on this topic. The creations were often revised later by the artists or mounted on other pedestals. The Meissen figurines were mainly based on artwork by such artists as Jacques Callot, Louis Riccoboni, Antoine Watteau, Johann Jakob Wolrab and others.

A regulation dating from 1684 stated that the troop of comedy players must consist of 12 actors and actresses: two ladies for serious roles and two for comic roles, two cavaliers as amorous characters, two men for comic roles, two men to create the intrigue and two old men of the type of Pantalones and Dottores. These pairs were preserved in the Meissen figurine series, and each figurine is linked with other characters, like on the stage.

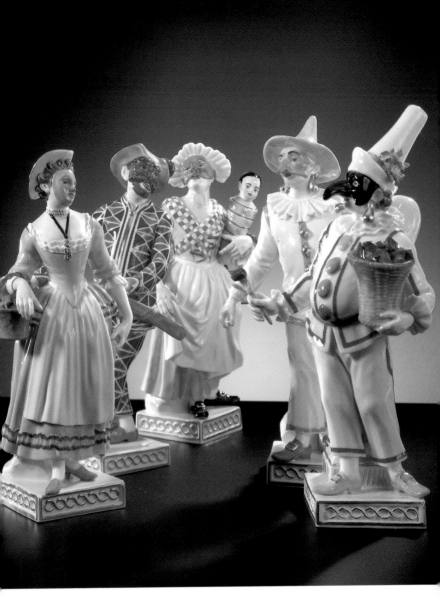

Figures from the "Commedia dell' arte" series,
modelled by Johann Joachim Kaendler, 1771–1775

As hunting was one of the main pleasures of courtly life, it was natural that hunting topics should be treated in a wide variety of 18th-century designs in Meissen porcelain. The porcelain artists created a large number of individual figurines and groups on this topic. Valuable tableware services, bowls, dishes and vases were decorated with intricate hunting scenes based on copper engravings by Johann Elias Ridinger. The relationship between humans and animals in hunting was portrayed, as were the animals in general. Hunting also offered numerous ideas for imposing animal sculptures, and the dog, as fellow hunter of the humans, played a special role in this area. This was continued in the 19th century in isolated, impressive animal figures.

In the 20th century, another extensive hunting tableware service was created with various figurines showing the hunting scenery of the 1970's. The vessel forms "Great Cutout" were developed by Ludwig Zepner, the animal figures by Peter Strang and the decors "Hunt Painting", "Waterfowl Hunting" and "Hunting Lore" were created by Heinz Werner. The decor painting is a combination of underglaze and overglaze painting. In the modern reproductions of old models, connoisseurs particularly appreciate the historic portrayals of humans and animals and the high quality of the artistic design of these small figurines.

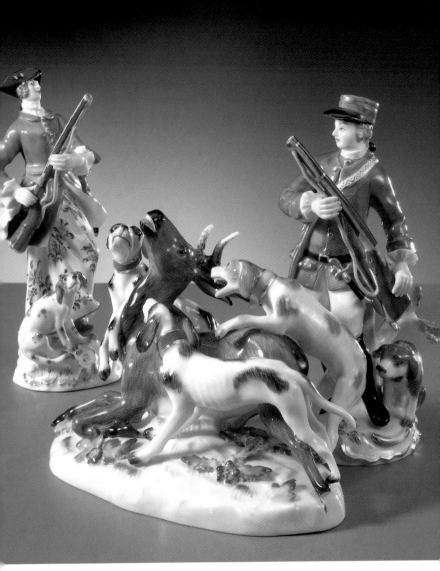

Group "Stag Hunt", "Huntress with Dog", "Hunter with Dog",
models: 18th century

Traditional wine cultivation on the slopes of the Elbe near Dresden, Radebeul and Meissen, the stimulation of wine drinking and the Dionysian world of antiquity were reflected in many ways in Meissen porcelain in the 18th, 19th and 20th centuries. The designs range from appealing vintners' children with their various implements through portrayals of grape harvesting and wine presses to the pictures of merry wine festivals with song, dance and revelry.

Another strand represents the figures of antiquity such as Venus and Bacchus.

In all periods, there were also splendid still life paintings with fruit, including grapes and other kinds of fruit. In particular, the decor "Full Green Vine Wreath", which was created in 1817, also expresses a local aspect. In recent times, another decor was created which was dedicated to the subject of wine. In chrome oxide green underglaze paint and green soluble paint, Heinz Werner created the decor "Vine Leaf with Grape". Wine pitchers and wine cups supplement the range along with large and small wall plaques with attractive motifs.

Vintner group "The Wine Harvest", model: around 1754

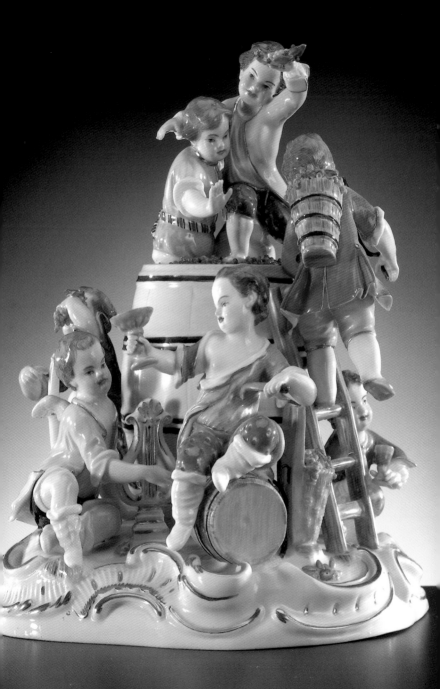

As the material prosperity of Saxony and the splendour of the court at Dresden were largely based on the income from the highly developed mining and foundry industry, mining work was honoured in many ways, and this is also reflected in numerous figurines and painted decors in Meissen porcelain.

The ideas for the artistic design of this subject certainly came from various previously existing works, such as pictures of the ceremonial procession or miners' parade in Plauen Valley (near Dresden) in 1719 on the occasion of the marriage of Crown Prince Friedrich August with Maria Josepha of Austria, or Johann Christoph Weigel's "Illustration and description of all mining and smelting foundry officials and servants according to their normal rank and order in their appropriate mining uniform ...", which was published in 1721 in Nürnberg. Especially magnificent were the small and large table decorations in which several figures portrayed the sequence of activities involved in mining work.

In decor painting, two Meissen painters are particularly known for their mining scene paintings: Bonaventura Gottlieb Häuer (approx. 1709–1782) and Carl Christoph Thiele (1714/15–1796). The portrayals showed all areas of mining and foundry work below and above ground, the family life of the miners in the evening and mining boys at play in their free time. Mining and foundry scenes and extracts from mines show the places where miners work and the type of work they did.

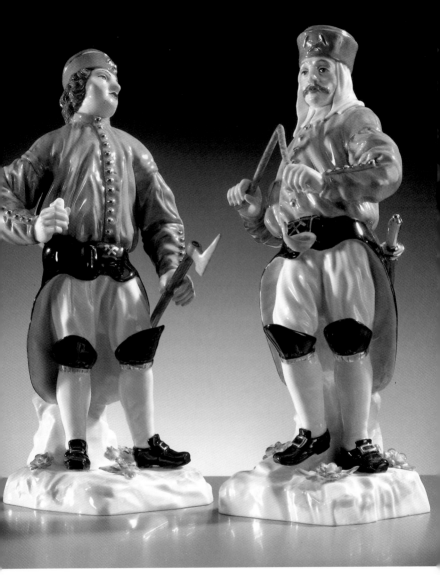

Figures from the "Miners" series, modelled by Johann Joachim Kaendler, around 1750

The "Monkey Orchestra", consisting of 21 figures (and a music stand), is regarded as a masterpiece of 18th-century Meissen porcelain figurines. Johann Joachim Kaendler created a first version of this musical group of monkeys around 1753. After the Seven Years War, around 1765/66, the design was revised in cooperation with the porcelain sculptor Peter Reinicke.

The Saxon satirical poet Gottlieb Wilhelm Rabener, a contemporary of Kaendler, described in an essay of 1745 a fable based on Aesop and a copper engraving by Jean-Jacques Filipart in which there is a "school of the monkeys" in which the monkeys are disguised as humans and "only act sensibly out of compulsion". In a lexicon of 1732 it was stated: "The monkey is a symbol of a useless person because he merely serves to pass the time of day; an idle person receiving undeserved honour, because he does not become human by just putting on human clothes …"

In an apparently amusing and comical design of this group of monkeys, Kaendler presented in cryptic form an anti-feudal and anti-courtly mentality which honoured the free citizen, the sensible human - irrespective of his birth and origins. The "Monkey Orchestra" is still produced today in intricate work by hand, and is enormously popular among connoisseurs of Meissen porcelain.

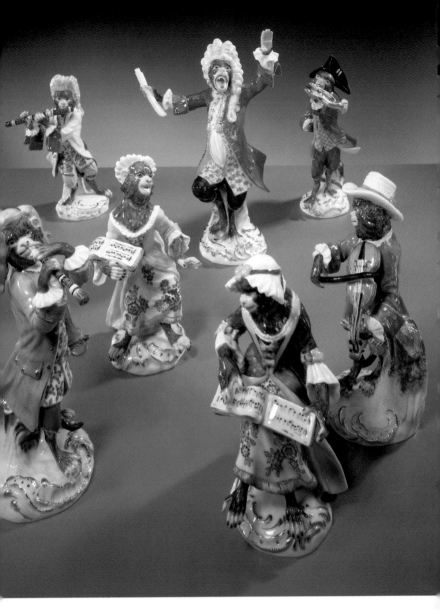

Figures from the "Monkey Orchestra",
modelled by Johann Joachim Kaendler, around 1765

Like a seismograph, Meissen porcelain registered the impending social changes in Europe. After the Seven Years War, Enlightened Absolutism created favourable conditions for the economic development of the bourgeois classes and the dissemination of liberal thinking, so that this period in history can be regarded as a direct precursor of the bourgeois age.

The search for an artist who would be able to transfer the new, bourgeois values to Meissen porcelain in an artistic manner led to the young Parisian sculptor Michel Victor Acier (1736–1799). Acier was appointed to the Meissen manufactory on August 3, 1764. He worked alongside Kaendler as a master modeller, and up to his retirement from the manufactory in 1780 he created about 200 figurines and groups of figures which fully reflected the new taste. Problems of childrearing, morality, family and marriage, children, etc., were expressed in a contemporary manner in his works. His artistic style had an unmistakable air of strict seriousness, but that was a necessary consequence of his subject matter. His moral cause was always portrayed in a loving way that was faithful to detail.

His figurines are still in demand today. His "Motto Children" are particularly appreciated – they are small cupids bearing aphorisms.

Group of figures "The Good Mother", modelled by Michel Victor Acier, 1774

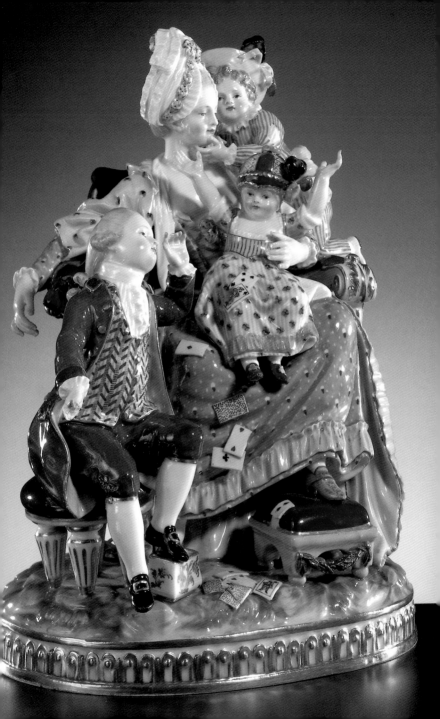

In the Enlightenment period, antiquity was regarded as the "Golden Age" of human history, and studying antiquity was seen as a practical step towards the renewal of society as a whole. Excavations in Herculaneum (dating from 1738) and Pompeii (dating from 1748) provided artistic stimulus for the entire Western world.

Meissen porcelain artists found their inspiration in various copper engravings based on artifacts of antiquity and in the antique sculptures in the Royal Collection in Dresden. Christian Gottfried Jüchtzer (1752–1812), who began working at the manufactory in 1768, initially worked under Kaendler and Acier before he himself became a master modeller in 1794 and received the decision-making authority associated with that position. As of June 1796 he was permitted to spend the summer months in Dresden to design appropriate models based on works from antiquity. Most of his creations originated from these visits. He translated innumerable sculptures based on Greek and Roman models into Meissen porcelain. The "Three Graces" are still popular among connoisseurs of Meissen porcelain today. The work shows Aglaia (the Splendid), Euphrosyne (the Merry) and Thalia (the Blossoming).

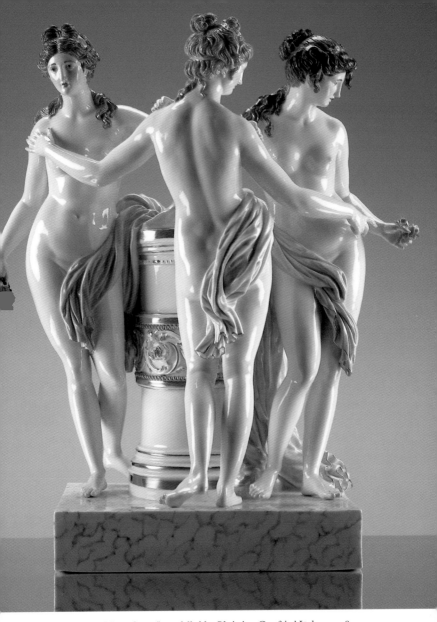

Group of figures "Three Graces", modelled by Christian Gottfried Jüchtzer, 1784

This decoration, for which the proper title is "Full Green Wine Wreath", was created in the Meissen Porcelain Manufactory in 1817 – after several years of experimental attempts – as a chrome oxide green underglaze painting motif. The decor designer was the Meissen flower and landscape painter Johann Samuel Arnhold (1766–1828). The vessel shapes of the "Service with the Swan Neck" were created by the Meissen modeller Johann Daniel Schöne (1767–1843) between 1814 and 1818. The design of the tall vessels is borrowed from the antique form of the amphora, and the design of the service itself is a deliberate and rather subtle homage to antiquity as understood by bourgeois artists in the early 19th century.

This decoration also shows its inimitable charm on the traditional forms of the 18th century, such as the "New Cutout".

With the Saxon state colours of white and green, which were made official in 1831, the significance of the decor achieved a new level of popularity.

The decoration, with and without a gold edge or gold patterns on the leaves, could be adapted for all purposes, from garden parties to festive table designs. Without gold the decor is classed as dishwasher safe, so that it is admirably suited for everyday use.

The decor was awarded the 1992 German Wine Prize.

Parts of a service with decor "Full Green Wine Wreath"
by Johann Samuel Arnhold, 1817, modelled by Daniel Schöne, 1815

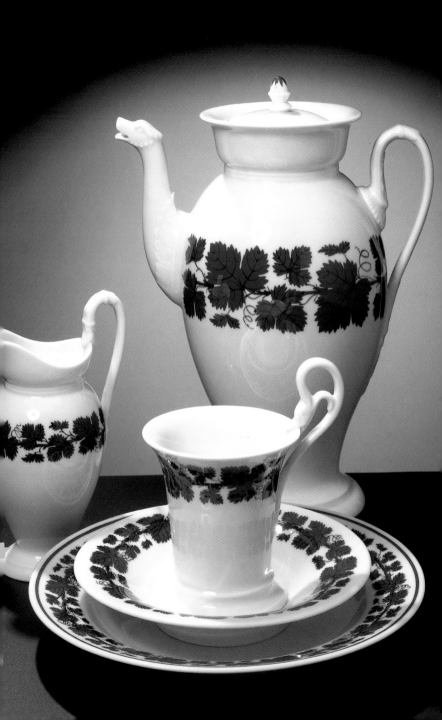

During the Biedermeier period (approx. 1818 to 1848), small flower patterns were dominant, but there were also decors with typical stripe patterns and the popular decors with initials. The vessels were largely delicate in form, the cup handles generally projected above the drinking rim. The decoration "Scattered Flowers" – in many colour variations and with different combinations of flowers – belongs to the genre of Meissen "Stylised Flower Painting". The decoration draws its vitality and fascination from the apparent improvisation in the scattered arrangement of the flowers, which creates an association of grace and lightheartedness, and probably also involves a reference to the German custom of throwing flower petals at weddings.

The "Scattered Flowers" decors became the most popular paintings of the Meissen manufactory, and they are still popular today. The great variety and many colours of the scattered flower patterns provides just as many options for today's purchaser.

Parts of a service with decor "Scattered Flowers", modelled by Johann Daniel Schöne, 1815

The technical and technological changes in the manufactory between 1814 and 1864 (conversion of the kilns to coal in 1839; first steam machines in 1852/53) made it necessary to consider relocating the manufactory. In particular, the Saxon Art and Antiquity Society urged relocation in order to prevent the Albrechtsburg from suffering the damage which was anticipated as a result of the new technology.

In 1852, the Ministry of Finance asked for an estimate for relocation. In 1857, a project was proposed which envisaged the Triebisch valley as the site of the manufactory. In 1858, the state parliament approved a sum of 300,000 Talers for the construction, so that the first five wings of the new building could be built between 1859 and 1863.

View of the manufactory in the Triebisch valley, after 1865, drawing after Adolf Elzner

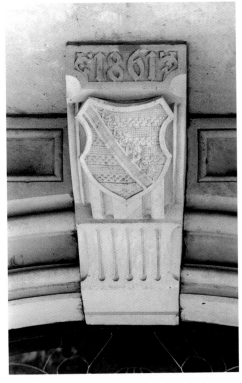

Capstone of 1861 avove the main entrance
to the porcelain manufactory

The relocation of the manufactory was completed by March 31, 1864. The next major structural, technical and technological changes took place in the 1970's and the 1990's.

However, the hand painting and embossing characteristic of Meissen remained unaffected by any innovations, in spite of technical progress and the modernisation of the buildings.

The participation of the Meissen manufactory in various world expositions was of major commercial and artistic significance, especially in terms of the survival of this last anachronistic industrial operation in the age of technological revolution. At the world expositions, the manufactory exhibited porcelain that could only be produced by traditional hand methods, and this repeatedly had to be made obvious.

It was particularly important that the manufactory took part in the world expositions in London in 1851 and 1862, in Paris in 1867, in Vienna in 1873, in Chicago in 1893 and in Paris in 1900.

The Meissen Porcelain Manufactory exhibited both traditional 18th-century porcelain and various contemporary developments. Although the world expositions mainly served to promote the commercial interests of the manufactory, it also provided guidance on artistic matters and the technology of porcelain. For example, as a reaction to the world exposition in London in 1851, the academic council was set up in the same year. This was an artistic committee which was made up of three representatives of the Dresden Art Academy and three representatives of the manufactory and which had the task of defining the artistic concepts for the future work of the manufactory.

In general, the world expositions were always a financial success (with the exception of Paris in 1867 and Chicago in 1893), and many orders were received. Particularly valuable exhibits are still included in the collection of the "Exhibition Hall".

Decorative chest, form and decoration by Ludwig Sturm, 1891/92, produced for the World Exposition in Chicago 1893

The year 1896 was the time when Art Nouveau began to have an effect on the design of Meissen porcelain. The first major achievements in the area of general porcelain tableware date from this year. In a competition, the twenty-four-year-old embosser Julius Konrad Hentschel (1872–1907) designed the famous "Crocus Breakfast Set", which eventually met with great acclaim at the world exposition in Paris in 1900. The "Snowdrop Pattern" by Rudolf Hentschel (1869–1951) dates from 1899. The service form "T Smooth" of 1901 was specially developed for the modern decorations of Art Nouveau. In the same year, Rudolf Hentschel also designed the decor "Wing Pattern" for this service form, in 1904 Franz Paul Richter designed the "Maple Pattern", Arthur Barth designed the "Primrose Pattern" in 1906 and Rudolf Hentschel designed the "Arnica Pattern" in 1907.

In 1902 the manufactory came into contact with Henry van de Velde (1863–1957), and starting in the spring of 1903 he also contributed to designs for new service forms and decors. The collaboration with Richard Riemerschmid began in February 1903, and the last corrections to the "Riemerschmid Service" were made in the summer of 1905.

The main Art Nouveau figurines were created by about 1910. Only the "Hentschel Children" by Julius Konrad Hentschel have stood the test of time and still meet with the interest of porcelain connoisseurs. In 1998 the candlesticks "The Three Wise Men from the East" by Erich Kleinhempel and parts of the "Saxonia" service of 1904 by Otto Eduard Voigt were reproduced again for the first time, which indicates a growing interest in this style.

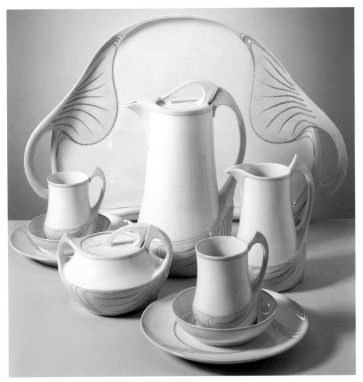

Children's figures by Julius Konrad Hentschel dating from 1905 und 1907
Art Nouveau breakfast service "Saxonia«, model and decor: Otto Eduard Voigt, 1904

In the 19th century, only very few new models for animal sculptures were developed in Meissen. Important stimulus for modern porcelain animal figures was provided by the Copenhagen manufactory at the end of the century. Its works set new standards and were in demand throughout the world around 1900. The porcelain artists in Meissen also devoted themselves to this phenomenon and came to a new view of the artistic possibilities of animal sculptures. From about 1903 on, the new bright-fire paints with their suggestive "body warmth" and softly flowing colour tones were used to decorate the animal figures. Usually, an extremely sensitive portrayal of the animal's character was dominant, as if approaching the animal slowly without frightening it. Under the leadership of Erich Hösel (1869–1953), himself an excellent animal modeller, the modellers were given a large degree of artistic freedom, and the modeller Paul Walther (1876–1933) achieved outstanding stature. He created the most impressive animal sculptures of the early 20th century with the most appropriate use of the materials. But Hösel also encouraged the purchase of models from outside artists such as the Dresden sculptor Otto Pilz (1867–1934) and Otto Jahrl (1856–1915). At the beginning of the 1920's the manufactory appointed the sculptor Max Esser (1885–1945), an artist who brought unorthodox design principles to the work. He modelled smooth forms, texturing only surface details, and provided accentuation by adding decorative elements. Other animal-figure designers were Willi Münch-Khe (1885–1961) and Erich Oehme (1889–1970).

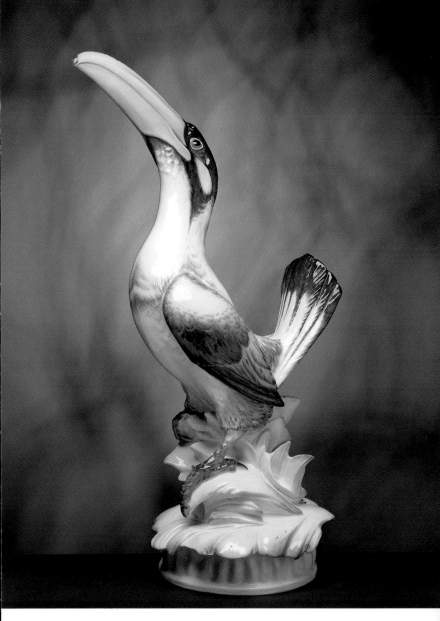

Pepper-eater (Toucan), modelled by Paul Walther, 1925

Between 1917 and 1918 the company chemist William Funk developed a new formula (mixing ratio for ceramic raw materials) for reddish brown fine stoneware (Böttger stoneware). The popularity of this material developed by Johann Friedrich Böttger in 1707/08 had declined after the invention of white porcelain, and it was forgotten in the course of time. Naturally, the timing of the new development was linked with celebrations in honour of the 200th anniversary of Böttger's death in 1919. The patent application was filed on April 30, 1919.

It seems certain that the initiator of this development was the ceramics technician Max Adolf Pfeiffer (1875–1957), who started working in the Meissen manufactory in 1913 and became its director in 1918. He is regarded as the outstanding innovator at the Meissen Porcelain Manufactory in the areas of ceramic technology and artistic design. In the following years, red fine stoneware was used in the design of several figures, for example "The Sleeping Vagabond" (1923) and the "Hovering God the Father" (1923) by Ernst Barlach. Figures designed by Gerhard Marcks included "The Sleepwalking Lady" (1919) and "The Candlestick Rider" (1920). Many animal figures by Willi Münch-Khe were designed specifically for the fine stoneware because the silky surface created special effects. The material was (and is) also used for badges, coins, medallions and lockets. Outstanding results were achieved with medallions, and they are greatly in demand among collectors.

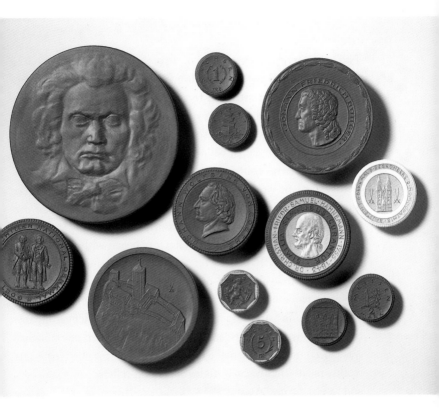

Medallions and coins of Böttger stoneware and porcelain

The extremely creative work of Paul Scheurich (1833–1945) is closely connected with Max Adolf Pfeiffer, who has already been mentioned. Pfeiffer attracted to the Meissen manufactory a large number of artists who had previously worked with him in his own company, the "Schwarzburg Workshops of Porcelain Art" in Unter-weissbach, Thuringia. In cooperation with them, Pfeiffer tried to keep in touch with contemporary developments in art in the manufactory's artistic work. At the same time, he strove for the highest quality in traditional areas in order to ensure the survival of the manufactory in troubled economic times.

Scheurich's work with the manufactory began with the "Figures from the Russian Ballet" in 1913. They show characters from the ballet "Le Carnaval" (based on Robert Schumann's piano cycle of the same name of 1834/35) which was danced in Berlin on several occasions in 1910 and 1912 by the Sergei Dhiagilev ballet company. Scheurich's work as a freelance artist for the Meissen manufactory was placed on a contractual basis in 1918. Up to 1937 he created 111 works, mostly figurines, but also including reliefs, badges, decors and vessel forms. At the Paris world exposition in 1937 he was awarded a Grand Prix for the figures "Reclining Person", "Lady with a Fan", "Abduction", "Lady with Hind", "Amazon with Amor" and "Falling Lady Rider".

Characteristic elements of Scheurich's works were the slender suppleness of his figures, the restrained, suggestive coloured decor and their cheerful, sensual expressiveness. He is undoubtedly the most important porcelain designer in the first half of the 20th century.

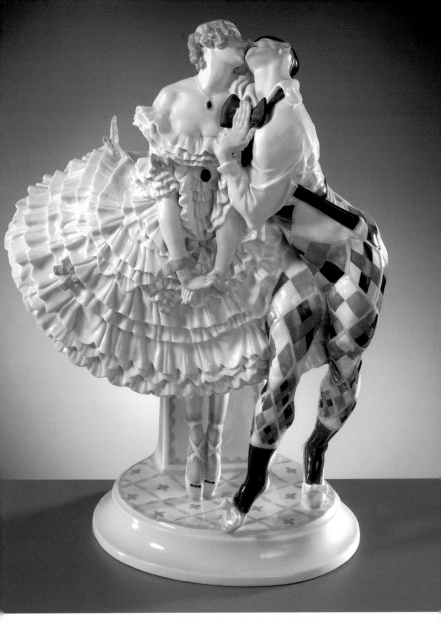

"Harlequin and Columbine" (figures from the Russian Ballet),
modelled by Paul Scheurich, 1913/14

The establishment of an artistic work team at the beginning of the 1960's laid the foundation for the systematic development of modern Meissen porcelain today. The original members of this group of artists were the form designer Ludwig Zepner (born 1931), the sculptor and figure designer Peter Strang (born 1936) and the painter Heinz Werner (born 1928). They were subsequently joined by the porcelain painters Rudi Stolle (1919–1996) and Volkmar Bretschneider (born 1930). All the members learned their trade in the manufactory and followed this with academic studies and study trips. The unifying working principle of these artists was their joint output. Each of them had to subject himself to the group's overall concerns without giving up his individuality – a delicate balancing act!

Forms and decorations, figurines and colouring were jointly conceived and implemented. Porcelain works were created which were convincingly consistent in all their details. All available painting techniques were used. New creations were presented every year at the trade fairs in Leipzig and Frankfurt am Main. The five artists finally earned success and renown, and the modern Meissen porcelain created by them became established. The group achieved its first success with the service design "Münchhausen" of 1964 (based on the novel of the same name by Gottfried August Bürger about a notorious mischiefmaker), in which a decor suitable for the manufacturing process and in keeping with tradition was combined with a coloured background and figurine painting.

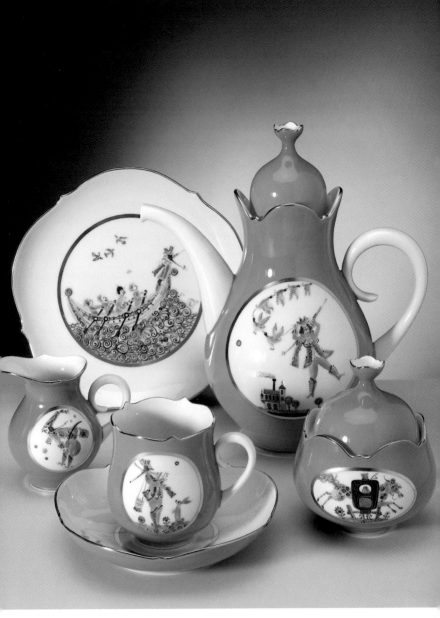

Parts from a coffee service, model: "Large Cutout" (since 1973) by Ludwig Zepner,
decor: "Münchhausen's Adventures" (since 1964) by Heinz Werner

Ludwig Zepner developed comprehensive, extensive and coherently consistent table service sets like no other form designer before him. His numerous form designs are elegant, generous, dynamic, suitable for the manufacturing process and ideal surfaces for the porcelain painters to work on. Zepner's service complex "Large Cutout" originated in 1973, and was successfully extended well into the 1980's.

In 1974, Heinz Werner created the decor "Arabian Nights" in a painted version, thus creating a valuable porcelain painting work which continued traditions and at the same time included new departures. The figure-based scenes, which are imaginative and graceful, are characterised by a lively richness of movements, and the figures are placed in a richly decorated oriental setting which is suggestive of both indoor and landscape contexts. This decoration illustrates the exclusive modern Meissen painting culture in all its perfection. The unbounded acclaim achieved by this table service creation gave the artists the courage and confidence to continue working systematically along the same lines. Ludwig Zepner once said: "If a fruitful and courteously conducted critical exchange of opinions continues, if tradition is understood as an ongoing development and if modern technical and technological achievements and the boldest of artistic visions remain the values upheld by Meissen, then I am optimistic that the old and venerable porcelain will remain young."

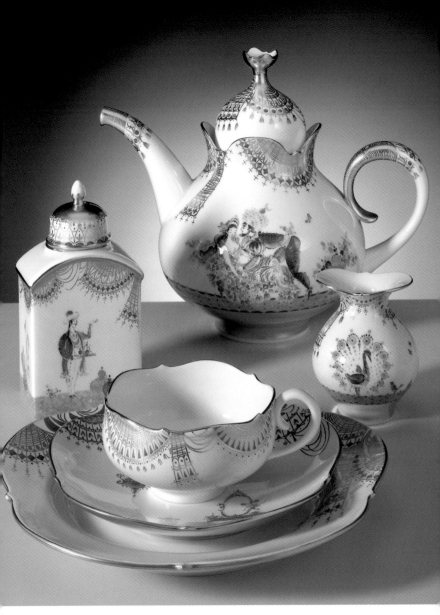

Parts from a tea service, model: "Large Cutout" (since 1973) by Ludwig Zepner,
decor: "Motifs from Arabian Nights" (since 1974) by Heinz Werner

The porcelain world of Peter Strang

The sculptor and porcelain figurine designer Peter Strang (born 1936) learned the trade of an embosser in the Meissen Porcelain Manufactory. He trained as a sculptor at the College of Arts in Dresden. In his works the worlds of theatre, music, fairy tales and circus play a special role, and he also designed animal figures with great expressiveness. He is one of the porcelain figurine modellers who has worked continuously for the longest time for the Meissen manufactory, and he tried to realise his ideas of modern porcelain modelling in many ways. His artist colleague Heinz Werner commented: "Peter Strang's figures have character. Whatever subject he turns to, he can express all human sensations in generalised compositions with his modelling hands: calmness and motion, relaxation and tension, merriment and seriousness. He finds a unity of opposites in the medium of porcelain. In recent years, a deliberate reduction in his language of forms can be observed. More is expressed by less. A higher degree of abstraction and symbolisation places greater demands on the viewer." His means of expression are the seductive malleability of the material in conjunction with the special qualities of ceramic techniques, the enticing play of light and the visual attraction of the colours. His most recent creations can definitely be regarded as works of art.

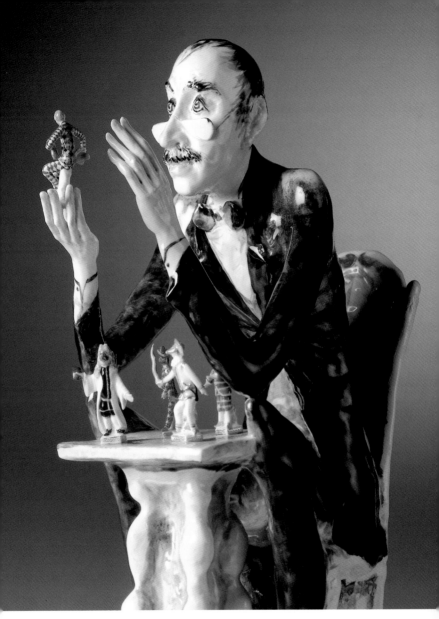

"The Collector" (based on the film "Utz"), modelled and decorated by Peter Strang, 1992

The subsequent generation of artists, including painter Gudrun Gaube (born 1961), form designer Sabine Wachs (born 1960), figure modeller Olaf Fieber (born 1966), painter Andreas Herten (born 1967) and figure modeller Jörg Danielczyk (born 1952) is expressing its own, unmistakable visions of Meissen porcelain in our time so forcefully and freely that it is obtaining corresponding results. The new decors, adornments, vessel forms, figurines, wall plaques and decorative objects are sometimes colourful and strident, sometimes restrained and gentle, sometimes provocative and unconventional, sometimes sophisticated and flexible. Andreas Herten, a pupil of Heinz Werner, and Olaf Fieber, a pupil of Peter Strang, both grew up with specific influences, became well acquainted with specific perspectives and have finally developed their own artistic identity. All have a masterful command of the traditional crafts of the "porcelain workers", they know the complications of developing designs and they create new visual spheres which are expressed in many different forms, from studio series and individual works to mass reproductions. The development is breathtaking and the fountain of creativity ever flowing – and more and more connoisseurs of Meissen porcelain accept works that are new and contemporary. Heinz Werner wrote about the change to the next generation: "We are in a close inner relationship with the young ones who intend to follow in our footsteps in the foreseeable future. But today they are building on different foundations than we had when we started. And they have a different experience. It is therefore not appropriate for us to be condescending towards them, they have to seek and find their own way."

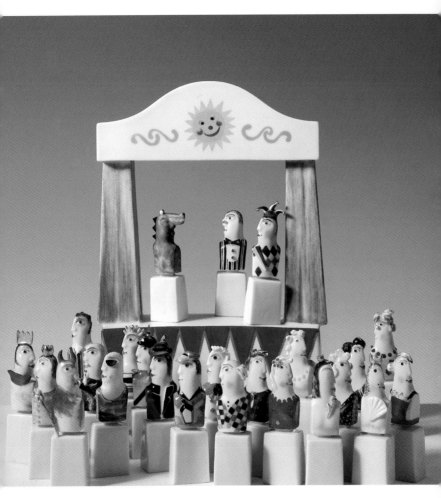

"Puppet Theatre", modelled and decorated by Olaf Fieber, 1997

The development of the tableware services "Wellenspiel" ("Waves") and "Wellenspiel, Relief" ("Waves in Relief"), which was designed under the leadership of Sabine Wachs in 1995/96 and supplemented and extended with a captivating surface texture by Jörg Danielczyk, fits in with the traditional design concepts of the clear outlines and curving, soft forms of Meissen porcelain. The vessel forms of the "Waves" tableware have a visual affinity with water in movement and waves of water in almost every detail. The aesthetically sophisticated surface texture underlines this impression in a creative way in that the line pattern also suggests sand wavelets under the surface of the water, or waves of sand in a gentle breeze. Both forms instill a sense of well-being and remind the viewer of sand, sun and the sea, a quiet pond with gently rippling waves, a glowing desert – and a period of relaxation far from the stress of everyday life.

The surface relief pattern carries on various Meissen traditions. The "Swan Service", with its surface texture based on sea shells, and relief patterns such as "Ozier", "Marseille", "Gotzkowsky", etc., comprised form designs of the 18th century which expressed certain sentiments in the style of the time. The different decors radiate an atmosphere of buoyancy and elation, stimulated by observation of nature and the sophisticated design arts of the present – whether they are adorned with colourful overglaze painting or cobalt blue underglaze painting, whether they are rich or restrained in their design. The passage of time will bring new decorations for this tableware service.

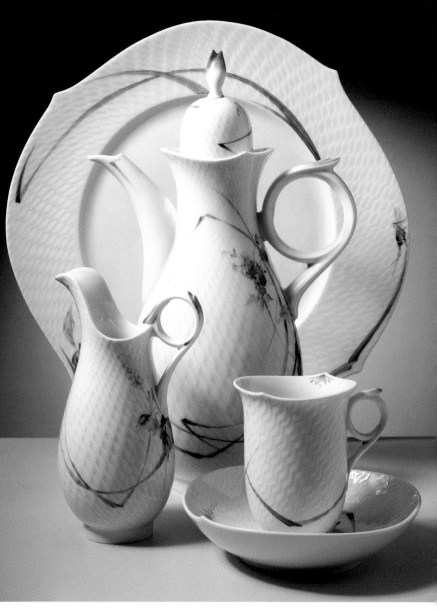

Items from the coffee service "Waves",
modelled by Sabine Wachs, Jörg Danielczyk, 1995/96,
decor: "Woodland Flora with Insects", Sabine Wachs, 1996

As early as the middle of the 18th century, paintings were transferred to porcelain sheets. The prerequisite was the production of flat and smooth picture tiles, an artistic command of the enamel paints for firing and the ability to control several colour firing cycles. In the main, famous paintings from the gallery in Dresden were copied. This development was continued in the 19th century, and the model archive of the manufactory has an enormous collection of paintings on porcelain. The artistic value of Meissen porcelain was convincingly demonstrated by this special branch of production. Many of the early porcelain painters had studied at the Dresden Art Academy. In the last third of the 19th century, the manufactory artists began to create their own picture motifs, and around 1900 Art Nouveau provided new impetus for the development of this branch of painting, in which bright-fire colours were specially used.

Now replicas are made, but completely independent and unconventional wall pictures and wall tiles are also produced, for which the picture designs are created by the manufactory's own artists. The wall picture has acquired specific dimensions and structures. It consists of one or more tiles or mosaic-type elements which are fitted together, with or without porcelain borders, and it may also include elements in relief which create three-dimensional pictures. The outstanding painters in this area are Heinz Werner, Rudi Stolle, Volkmar Bretschneider, Jörg Danielczyk, Horst Bretschneider, Sabine Wachs and Gudrun Gaube. All painting techniques are represented: overglaze and underglaze painting, solvent paints, pâte-sur-pâte painting and even pressing, textile impressions, material inclusions, etc.

*Modern porcelain wall pictures by Sabine Wachs (Tuscany Landscapes)
and Olaf Fieber (Figures)*

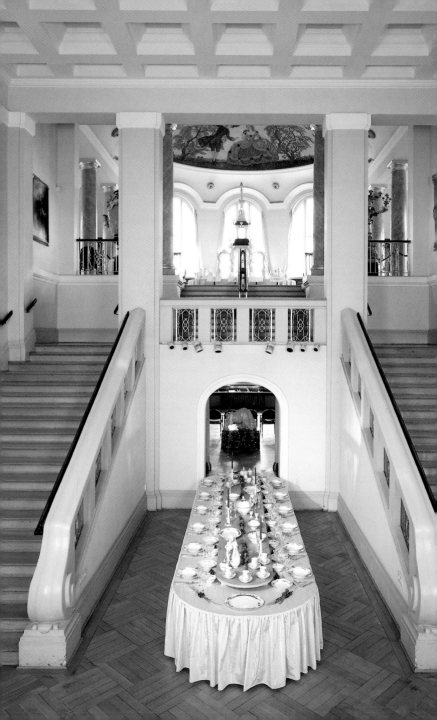

Appendix

The Drawing School of the Meissen Porcelain Manufactory was founded in 1764 as a branch of the Dresden Art Academy to counter the "decline of painting and sculpting arts". Prince Xaver of Saxony initiated this art school operated specifically for the manufactory. Previously, the developing "porcelain artists" had been taught painting and modelling skills by Johann Gregorius Höroldt and Johann Joachim Kaendler. The first director of the Drawing School was Christian Wilhelm Ernst Dietrich (1712–1774), a court painter and a professor at the Dresden Academy. The names of other famous artists are also linked with the Drawing School, such as Johann Eleazar Zeissig (called Schenau or Schönau) and Adrian Ludwig Richter.

The Meissen Drawing School is the oldest training institute connected with ceramics production in Europe. Completion of studies at the Drawing School is necessary in order to acquire the craftsmanship necessary for a career in painting and design. The Drawing School teaches the basic groundwork, especially the specific skills and abilities in line painting, surface painting and artistic drawing and painting methods. The basic drawing foundation includes the study of nature in relation to artistic practice, acquisition of creative abilities and faithful copying of models and patterns. Vocational training begins with a one-year course in the Drawing School. Candidates are trained to be ceramic figure modellers (with an option for further qualification as embossers), manufactory porcelain painters and industrial ceramic modellers. The vocational training lasts for three years. This training lays the foundation for successful work at the manufactory.

Examination piece in the Drawing School

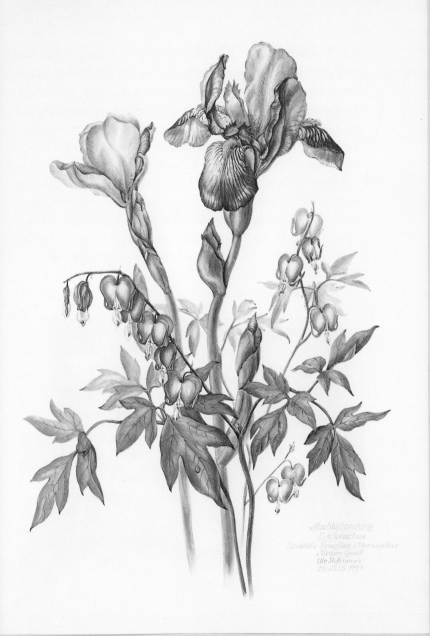

Abschlußprüfung
Zeichenschule
Staatliche Porzellan-Manufaktur
«Meissen» GmbH
Ute Hofmann
25.–28.05.1994

The "Exhibition Hall" building was built from 1912 to 1915 and opened on January 6, 1916. During the Second World War, a large proportion of the collection of models was moved to the Albrechtsburg. At the end of the war, the models were moved to what was then Leningrad. In 1958, the porcelain was given back to the manufactory, and it was first opened to the public in 1960 for the celebration of the 250th anniversary of the manufactory.

The exhibition in the "Exhibition Hall" is made up of the inventory of models of the manufactory's depot. Based on an enormous stock of models, the exhibition is partly redesigned almost every year so that rare or previously undisplayed models can show the variety and versatility of three centuries of Meissen porcelain.

Workplace of the turner and modeller in the Demonstration Workshop

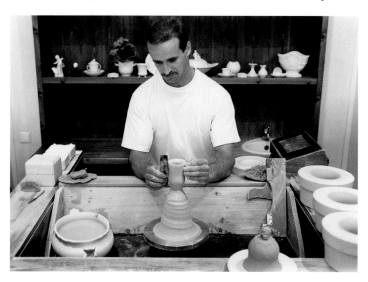

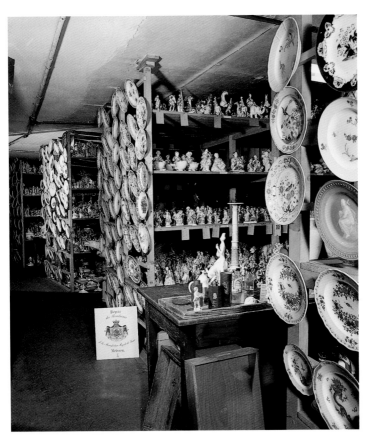

The stock of models in the Exhibition Hall

The exhibits – like all other porcelain products – also have a practical function as models, and where necessary they are loaned to the work stations of modellers, embossers and painters to enable production of faithful replicas.

Attached to the "Exhibition Hall" is also a "Demonstration Workshop", in which the production of Meissen porcelain is

demonstrated to visitors in selected areas. In four working rooms the visitor can follow the activities of turners, modellers, embossers, underglaze painters and overglaze painters. In an introductory lecture, the visitor learns interesting facts about the history of the manufactory, the raw materials and the technology used.

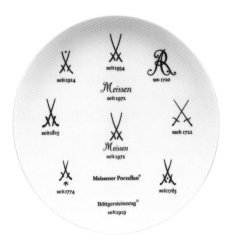

*Wall plate with a selection of trademarks
from the Meissen Porcelain Manufactory*

In November 1722, the manufactory inspector Steinbrück sugges-
ted using the Electoral swords from the Electoral Saxon coat of
arms to mark Meissen porcelain products. At the time it had be-
come necessary to mark the valuable porcelain: as of 1720 Meissen
porcelain products had become exclusive works of art because of
the paintings by Höroldt, and another porcelain manufactory was
established in Vienna in 1718. From 1722 to 1728 the "Crossed
Swords" were sometimes used to mark the porcelain, but not
systematically. August the Strong therefore had to command the
use of the marking in emphatic terms in 1729 and 1731. The letters
"KPM" or "KPF", used with or without the "Crossed Swords",
denote the "Königliche Porzellan-Manufaktur" (Royal Porcelain

Manufactory) or "Königliche Porzellan-Fabrique" (Royal Porcelain Factory). Under various directors, various elements were added to the "Crossed Swords", such as dots, stars, Arabic numerals, etc. On January 4, 1775, for example, the manufactory director Marcolini decreed that the "porcelain items produced under my direction … should from now on be marked with a star which should be placed directly below the Electoral swords". And from 1924 to 1934, during the period of Max Adolf Pfeiffer, a dot was placed between the top of the blades. Since 1919, the red fine stoneware has been marked with the name "Böttgersteinzeug" (Böttger stoneware), which is a protected trademark. And the logo "Meissen", with and without the "Crossed Swords", and the logo "Meissener Porzellan" are also protected trademarks.

These markings represent a binding and reliable quality commitment for purchasers of Meissen porcelain – anywhere in the world.

How porcelain is made – a brief digression

China clay – kaolin

The word kaolin comes from the Chinese. "Kao-ling" means "large mountain" and denotes the upland massif in the province Kiangxi where China clay was discovered. Kaolin occurs as a result of the weathering of quartz-porphyry, which is found in the sites where it originates in so-called primary deposits. The main component of kaolin is the mineral kaolinite. Since 1764 a high quality (i.e., especially pure) raw kaolin has been extracted for the Meissen porcelain manufactory near Seilitz, twelve kilometres from Meissen. Since 1825, this "white earth" has also been extracted underground, and is currently being mined in the fifth worked stratum, which corresponds to a depth of ten metres. A newly developed kaolin deposit in the immediate vicinity will supply the Meissen Porcelain Manufactory with this essential material in the future when the old deposit is exhausted. The Seilitz kaolin mine is regarded as the smallest mine in Germany and the oldest of all kaolin mines in Germany that are still in operation.

Porcelain as a material

Porcelain occurs as a result of change reactions in the high-temperature processing of a mixture made up of natural silicate raw materials. The preparation and mixing of the ingredients – generally kaolin, feldspar and quartz – creates a fine substance which is homogeneous in its composition. First, the raw kaolin is washed to remove mechanical impurities such as sand and stone. The resulting kaolin sludge is pumped into sedimentation tanks. Here, the mixture is left for up to three weeks to separate from the water. The watery layer is then pumped off and the wet kaolin sludge is processed further, i.e., it is mixed in drums with quartz and feldspar to

form the finished porcelain mass. The resulting mixture still has a high degree of moisture, which is removed in filter presses. The end product of this process consists of filter cakes of porcelain paste. Due to the moisture content, they are grey in colour.

These filter cakes are the raw material for two different forming processes. In one process, water is added to the paste to make "castable slip" (liquid porcelain mass), which is used to produce porcelain forms by casting. In the other process, the paste is prepared in a vacuum augur for throwing on a potter's wheel or for figurine modelling. Depending on the process to be used, different batch compositions are made. They can be ordered by the porcelain modellers with different degrees of moisture. The vacuum augur removes trapped air from the mass and produces a homogeneous consistency.

The model workshop

As the casting moulds (of plaster) become blocked during reproduction, the modellers must preserve the stock of moulds, or constantly renew them. In sculpted models, positive forms of the respective individual parts of a figurine or group of figures are made of modelling clay. These moulded parts must be meticulously worked on, then the figure can be put together (of modelling clay). The figure must then be cut into mouldable individual parts, and the modeller makes one or more marks at each cut and gives each part a number. In special containers the parts are passed on to the figure preparation specialist, who then casts a working mould of plaster for each part.

Part of the archive of plaster moulds

Throwing of hollow vessels

For the manufacture of bowls, dishes, cups, etc., the porcelain mass is thrown by hand in symmetric rotation on a potter's wheel. For particularly difficult items, such as oval tureens, this process in the Meissen manufactory is still carried out on a pedal-driven potter's wheel. First, the porcelain thrower forms the string of porcelain mass into a "clod", which is a freely thrown blank. This "clod" is placed into a plaster mould in which all of the elements of the later porcelain item are present as a negative impression. After a short drying period in which the plaster draws moisture out of the porcelain mass, the mould is removed. The thrower/modeller then smoothes the impurities that still exist and puts together items consisting of several parts.

Embossing

The major tasks of the embosser include adding relief to the parts produced in the working moulds in accordance with the tectonic design and with the aid of a model. This particularly applies to overlapping relief elements which can not be created in a mould and have to be added by the embosser. Models which were lost because of wear to the working moulds and processed mould and wedge seams must be finished. All steps of the work are carried out in accordance with the handwritten instructions of the original model designer. Relief forms and details such as folds, hands, faces and forms that create a special effect by their movement must be particularly accentuated in the modelling of the surface. When the parts are fitted together, the specific problems of seam tolerances, differences in space and double projections must be taken into account. The use of suitable firing aids also contributes much to the success of a figure; this includes the reinforcement and support systems in and on the moulded object.

Porcelain painting

The porcelain painters work with ceramic paints which are made durable by firing. These paints are actually coloured glass substances which are melted under, onto or into the glaze. These special features force porcelain painters to use particular painting methods. A general distinction is made between underglaze and overglaze painting. Underglaze painting is painted onto the fired object before the glaze is applied. The porous, absorbent porcelain quickly absorbs the paint, so that corrections are hardly possible. After the painting process, the porcelain object is completely covered with a white glaze. In the subsequent glaze, or sharp, firing process, the glaze becomes transparent like glass so that the painted decoration shows through. In this decoration method, only those paints can be used that can withstand the high firing temperatures of around 1400°C. The special characteristics of underglaze painting lie in the painting method, in the fact that it is usually in one colour only and in its resistance to external influences due to the fact that it is under the glaze and permanently linked to the actual porcelain. Probably the best-known blue underglaze decor is the Meissen "Onion Pattern".

In overglaze painting, the decoration is applied on the glazed and fully fired white porcelain object. The range of colours in this process is almost unlimited. The firing temperature for this third firing process (paint firing) is around 900°C. In this firing, the paint is melted onto the glaze and fuses with it.

Porcelain products from the manufactory retain a hand-made character and have individual features. The "handwriting" of the painters actually makes each object unique. Indian decors are stylised two-dimensional paintings. Presentations of animals, flowers and landscapes are portrayed in strictly linear and decorative forms. Each motif is defined exactly in its arrangement and colour com-

bination. The subdivision of the porcelain surface for these "fixed-template" designs is carried out by means of a hand-perforated metal film over which charcoal dust is sprinkled. The painter then has a guide by which to paint the defined decor by freehand painting.

In the painting of European motifs, an area of specialisation developed: flower painting. The varied flower decors which arose over the centuries can be subdivided into groups which are mastered by the flower specialists. The starting points for flower decors were botanical copper engravings of the 18th century. The translation of these designs into decorations on porcelain and the influence of the various epochs on the changing styles of portrayal have created the present flower painting motifs. First, the flower painter sketches the motif freehand onto the porcelain with a pencil. Then he can begin to apply coloured paint to the parts. That is the first stage of the painting work. After this application has been completed, the paint must first dry before the more detailed work can begin. Leaves and blossoms are painstakingly formed by depicting the shadows, by adding light and dark colours and by defining the pollen receptacles, petals and leaf stems in detail. Alongside the "Indian" style decors and European flower painting, landscape and figure painting were and are particularly important. The oldest known portrayals are copies based on oriental models. They were at their height in the imaginatively designed "Chinese-style illustrations" by Johann Gregorius Höroldt. Over the course of time, a large number of motifs have been added to these decors. Thus there are merchant motifs, seafaring paintings and various landscape and town pictures. The best known are probably the decors based on motifs by Antoine Watteau. Extensive collections of old copper engravings served as models for these decorations.

In contrast to all other types of painting, decorative painting aims to adorn relief porcelain. Completing relief designs with paint

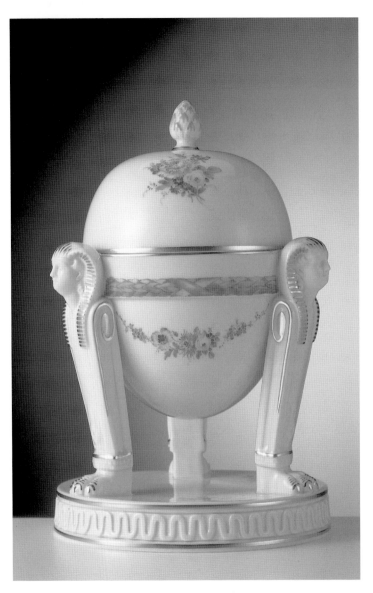

Ink-pott et the stile of classicism

is the task of the decorative painter. To do so, he uses a whole range of painting methods. The individual colour surfaces must be decorated in different colours, with Indian flowers, stripe patterns, diamond shapes, texture portrayals such as wood and marble – and even hair, skin, gold decorations and ornaments must be artistically designed with paint. The decorative painter has an extensive knowledge of fashion, uniforms, accessories and attributes.

The gold painter puts the finishing decorative touches on porcelain objects with precious metal mixtures suitable for painting. This work is carried out after the object has been decorated with the appropriate decor. The gold adornments range from a simple gold edge to complicated edges and cartouches. The gold painter's tools are a variety of brushes, different gold mixtures and the edging disc. He usually works with liquid polishing gold. This precious metal mixture tends to be matte when it comes out of the furnace and must therefore be polished. This is done with hard materials such as agate tools, fibre brushes or quartz sand. A different mixture with completely different properties is bright gold, which is already glossy when it leaves the furnace.

The Restoration Workshop

What can be done if the precious Meissen porcelain object should break?

Since 1996 there has been a restoration workshop in the manufactory, in which Meissen porcelain objects can be restored or repaired properly and in keeping with the original model.

Specialists with many years of experience, the existing model patterns and the manufactory's original raw materials and paints guarantee that the defective object can be restored to its former glory.

The figure "Lady Playing Bowls" after and before restoration

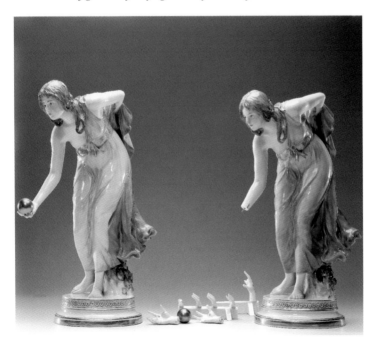

Restoration workplace

Porcelain that is historically especially valuable is assessed by the specialists, but it is normally only restored and not repaired. Restored objects are only partly suited for actual use.

The repair of an object is carried out by using all the available aids, and after the repair has been completed the object is completely suitable for use.

To be sure that a defective object can be restored or repaired, it is advisable to contact the restoration workshop department in writing first and to enclose photographs (cf. the details under "Important information", page 125).

Meissen porcelain has many good friends all over the world. In order to maintain and intensify these personal links with Meissen porcelain and the manufactory, the manufactory founded the club "Friends of Meissen Porcelain" in 1998.

Members of the club enjoy various privileges, such as a regular subscription to the informative newsletter "Meissen Briefe", free

Friendship Beaker for members of the club

admission for two to the Exhibition Hall and Demonstration Workshop, an exclusive offer to purchase a Meissen porcelain object from the annual, new "Collector's Edition", information about events, new publications, etc. Members pay an annual fee and receive a certificate of membership valid for one year.

Members of the club "Friends of Meissen Porcelain" are kept informed and looked after in the best possible way, and competent staff members are available for all questions and problems (cf. the details under "Important information", page 125).

For artistically interested painting enthusiasts, Meissen offers seminars for anyone to learn to create his own artistic work on porcelain. These seminars are open to both beginners and advanced painting enthusiasts, and they are taught by experienced instructors and artists of the Meissen porcelain manufactory.

The almost three hundred years of tradition in porcelain design and porcelain painting in the Meissen manufactory give some idea of the wealth of experience that goes into this course, with its emphasis on artistry and craftsmanship. As early as 1764, future artists were taught at a special art school in the Meissen Porcelain Manufactory. This vocational training is still carried out in an exemplary manner today. The "Meissen Porzellan® Painting and Creativity Seminars" are firmly rooted in this tradition. Theoretical drawing

Workplace in the Painting and Creativity Seminar

seminars and subsequent watercolour seminars form the beginning of a learning process – a school of visualisation.

Porcelain painting seminars ranging from simple to advanced subjects introduce the participants to the fascinating world of cheerful and attractive Meissen flower painting. They also provide insights into the world of the charmingly ornamental Meissen decors. Versatile "Indian painting" is closely linked to the unique character of oriental art.

Participants have full access to the demonstration workshop of the Meissen porcelain manufactory and the Exhibition Hall with its unique collection of Meissen porcelain. The seminar also includes visits to various workplaces in the manufactory to see painting in progress.

Meissen porcelain from the "Hobby Collection" provides the painting surface for the work in our painting seminars (cf. the details under "Important information", page 125).

Photograph credits

Recommended reading

Meissener Blaumalerei aus drei Jahrhunderten (Three Centuries of Meissen Painting in Blue). Edited by K.-P. Arnold and V. Diefenbach. Catalogue of the 1989 exhibition in Dresden (March to July 1989) and Hamburg (September – November 1989). Leipzig, 1989

Meissener Konturen (Meissen Contours). Porcelain by L. Zepner, H. Werner, P. Strang, R. Stolle, V. Bretschneider. 1960 to 1990.

Catalogue of the Exhibition in the Museum of Arts and Crafts in Leipzig, Grassimuseum (September 1991 – January 1992) and the Keramion Museum of Contemporary Art, Frechen (February to April 1992)

Meissener Manuskripte. Journal der Staatlichen Porzellan-Manufaktur Meissen (Meissen Manuscripts. Journal of the State Meissen Porcelain Manufactory). Regular series and special issues. Meissen, from 1992.

Menzhausen, Ingelore; Karpinski, Jürgen (Fotos): Alt-Meissner Porzellan in Dresden (Old Meissen Porcelain in Dresden). Berlin, 1989.

Miedtank, Lutz: Zwiebelmuster. Zur 300jährigen Geschichte des Dekors auf Porzellan, Fayence und Steingut (Onion Patterns. The 300-year-History of the Design on Porcelain, Faience and Stoneware). Leipzig, 1991.

Pietsch, Ulrich: Johann Gregorius Höroldt (1696–1775) und die Meissener Porzellanmalerei (J. G. Höroldt and Meissen Porcelain Painting). Exhibition catalogue, exhibition in the Porcelain Collection in the Zwinger, Dresden, 4.6.–30.10.1996. Leipzig 1996

Pietsch, Ulrich: Meissener Porzellan und seine ostasiatischen Vorbilder (Meissen Porcelain and its East Asian Models). Leipzig 1995.

Porzellansammlung im Dresdner Zwinger (The Porcelain Collection in the Dresden Zwinger). Guide to the permanent exhibition. Texts by A. Loesch, U. Pietsch, F. Reichel. Dresden, 1998.

Reinheckel, Günter: Prachtvolle Service aus Meissner Porzellan (Splendid Tableware Services in Meissen Porcelain). Leipzig, 1989; Stuttgart, 1990 (under: Meissen Splendid Services).

Sonntag, Hans: Die Affenkapelle aus Meissener Porzellan (The Monkey Orchestra in Meissen Porcelain). Frankfurt a. M.; Leipzig, 1993

Sonntag, Hans; Karpinski, Jürgen (photographs): Die Botschaft des Drachen. Ostasiatische Glückssymbole auf Meissener Porzellan (The Message of the Dragon. East Asian Good Luck Symbols on Meissen Porcelain). Leipzig, 1993; 1999 (2nd edition).

Sonntag, Hans; Karpinski, Jürgen (photographs): Erlebte Kunst. Meissener Figurenporzellane aus drei Jahrhunderten (Experienced Art. Three Centuries of Meissen Porcelain Figures). Leipzig, 1997

Sonntag, Hans: Meissener Porzellan. Bibliographie der deutschsprachigen Literatur (Meissen Porcelain. Bibliography of the Literature in German). Leipzig 1994

Sonntag, Hans; Karpinski, Jürgen (photographs): Meissener Porzellan. Eine kleine Galerie (Meissen Porcelain. A Small Gallery). Würzburg, 1996.

Sonntag, Hans; Karpinski, Jürgen (photographs): Meissener Porzellan. Schönheit im Detail (Meissen Porcelain. Beauty in Detail). Berlin, 1991; Leipzig, 1998 (2nd edition).

Sonntag, Hans: Schauhalle der Staatlichen Porzellan-Manufaktur Meissen. Führer durch die Sammlung (Exhibition Hall of the State Meissen Porcelain Manufactory. Guide to the Collection). Brunswick, 1991, 1992, 1994.

Sonntag, Hans; Karpinski, Jürgen (photographs): Die Sprache der Blumen (The Language of Flowers). Leipzig, 1995.

Sonntag, Hans; Karpinski, Jürgen (photographs): Verwandlungen. Literarische Figuren in Meissener Porzellan (Transformations. Literary Figures in Meissen Porcelain). Leipzig, 1999.

Sterba, Günther: Gebrauchsporzellan aus Meissen (Functional Porcelain from Meissen). Leipzig, 1988; Stuttgart, 1989 (under: Meissen Tableware).

Walcha, Otto: Meissner Porzellan. Von den Anfängen bis zur Gegenwart (Meissen Porcelain. From the Beginnings to the Present). Dresden, 1973, 1979, 1986.

Important information

Address

Staatliche Porzellan-Manufaktur Meissen GmbH,
Talstrasse 9, D-01662 Meissen
Telephone and fax numbers of selected departments:

Switchboard
Tel.: +49 (0) 35 21/46 80; Fax: +49 (0) 35 21/46 88 00

Tourism/Public Relations Department
Tel.: +49 (0) 35 21/46 82 08; Fax: +49 (0) 35 21/46 88 04

Restoration Department
Tel.: +49 (0) 35 21/46 86 07/46 86 08; Fax: +49 (0) 35 21/46 88 00

Club "Friends of Meissen Porcelain"
Tel.: +49 (0) 35 21/46 87 77; Fax: +49 (0) 35 21/46 87 76;
e-Mail: Club@meissen-club.com

Painting and Creativity Seminars
Tel.: +49 (0) 35 21/46 83 53/46 87 00; Fax: +49 (0) 35 21/46 87 75

Facilities open to visitors

Exhibition Hall/Demonstration Workshop:
Mon–Sun, 9–18 hrs. (May 1–Oct. 31); 9–17 hrs. (Nov. 1–Apr. 30)
Museum Shop:
Mo.–So., 9–18 hrs. (May 1–Oct. 31); 9–17 hrs. (Nov. 1–Apr. 30)
"Café Meissen": Mon–Sun, 9–18 hrs. (May 1–Oct. 31);
9–17 hrs. (Nov. 1–Apr. 30)
Closing times: December 24–26, December 31, January 1.

Contents

Millennial Meißen 5

The history of the Meissen Porcelain Manufactory from the 18th century to the present day 23

Impressum

The terms "Böttger stoneware" and "Meissen porcelain"
which are used in this book do not merely designate materials;
they are translations of the following legally protected trademarks
of the Meissen State Porcelain Manufactory:
Böttgersteinzeug®
Meissener Porzellan®

English translation: Victor Dewsbery, Berlin
Proofreader: Peter Jungkunst, New York

Cover design, layout and typography:
Atelier für grafische Gestaltung, Leipzig
Reproduction: Förster & Borries, Zwickau
Printed by: Westermann Druck, Zwickau
Printed in Germany
Printed on non-ageing paper made of cellulose bleached without chlorine.